STEP-BY-STEP POSING
FOR PORTRAIT PHOTOGRAPHY

Jeff Smith

AMHERST MEDIA, INC. ■ BUFFALO, NY

Published by:
Amherst Media, Inc.
P.O. Box 586
Buffalo, N.Y. 14226
Fax: 716-874-4508
www.AmherstMedia.com

Publisher: Craig Alesse
Senior Editor/Production Manager: Michelle Perkins
Assistant Editor: Barbara A. Lynch-Johnt
Editorial Assistance from: Chris Gallant, Sally Jarzab, John Loder
Business Manager: Adam Richards
Marketing, Sales, and Promotion Manager: Kate Neaverth
Warehouse and Fulfillment Manager: Roger Singo

ISBN-13: 978-1-60895-451-3
Library of Congress Control Number: 2011942803
Printed in The United States of America.
10 9 8 7 6 5 4 3 2 1

Check out Amherst Media's blogs at: http://portrait-photographer.blogspot.com/
http://weddingphotographer-amherstmedia.blogspot.com/

TABLE OF CONTENTS

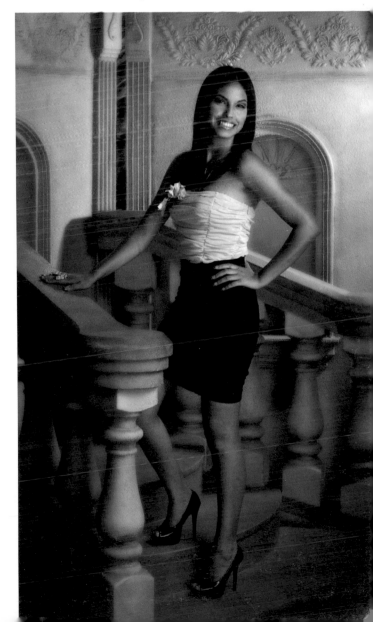

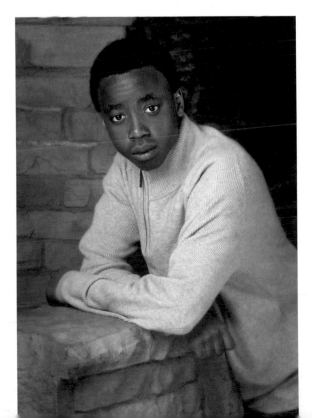

INTRODUCTION

There are so many aspects to professional photography: lighting, composition, camera angles, exposure, color balance, and of course posing. While each of these is important in the creation of a professional portrait, posing is unique. I can teach a staff photographer to set up lighting, then meter and color balance my lighting properly in about six months. I can teach someone critical lighting adjustment in about two years. Composition and camera angles might take a little longer. But posing is something that typically takes years to master—and quite frankly you never *completely* master it because, if done correctly, it is constantly evolving.

LEARNING MEANS DOING

This book is different from the others I have written on posing. While I will be explaining the many aspects of posing, this book relies heavily on the illustrations to show you exactly how to pose each type of client. If you have read one of my other books on posing, you may see some things you have read about before—but the question isn't whether you have *read* it before, but whether you have actually put the information to *use*. This book will do you no good if you don't take it to your studio or outdoor location with a subject to practice on and put all the techniques to use.

You can't learn posing just by reading a book—or, for that matter, by memorizing the entire range of poses you see in this book. You have to practice the poses you see and learn to make adjustments in the poses for variables, such as height, weight, and body size. A pose that looks amazing on the person you see in this book might not look the same on the first person you pose. Differences in a person's proportions, flexibility, and even how comfortable or rigid the person is in front of the camera, make a huge difference in the way they look in any given pose.

You also have to use common sense when posing and avoid making clients get outside their comfort zones. While a family portrait might look great with the grandmother kneeling or lying in the middle of the group, if she is old and unable to get down to the ground and back up, her discomfort in having to be helped into the pose will make her look tense no matter how comfortable you try to make her in the pose. The same is true for dads and grandfathers. If you make their poses too fashionable or hard to get into, the unique look of the pose will be overshadowed by their uneasiness. With small children, it is much more comfortable to bring the adults down to their level than to bring them up to the level of the adults.

REAL PEOPLE

In all my books, I show clients, not models. It does you no good to learn how to pose perfect people from a book and then work daily in the studio with non-perfect clients. In our studio, we specialize in senior portraits, which means that a good portion of the people in this book are high school seniors.

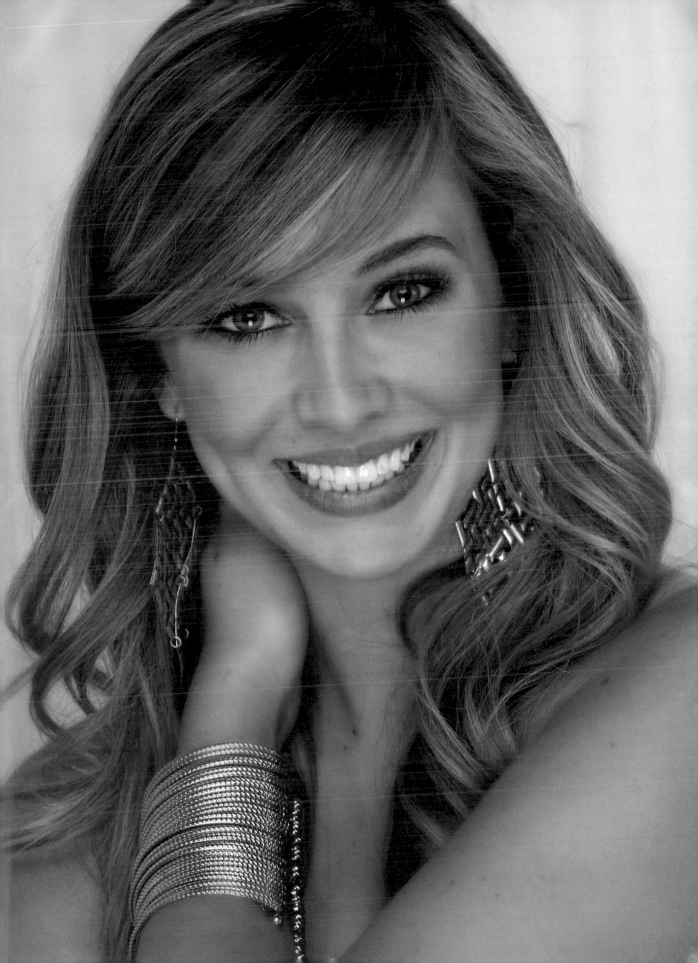

1 OBJECTIVES OF GREAT POSING

Posing can help achieve many of the things that are vital to creating a professional-quality portrait—a portrait that a client will buy.

Make the Client Look Great

Posing, first and foremost, must make the client look amazing. You must understand how each part of the face and body is best posed, and then bring together all the individual parts to make the entire pose successful.

Make the Pose Suit the Composition

Once you make the client look amazing, you must ensure that the pose you've used works well within the composition. It should contribute to an overall finished and professional look. You can't have a portrait that is "out of balance" because the pose doesn't work within the composition or with the way you have chosen to crop the image.

When posing, the first objective is to make the subject look great.

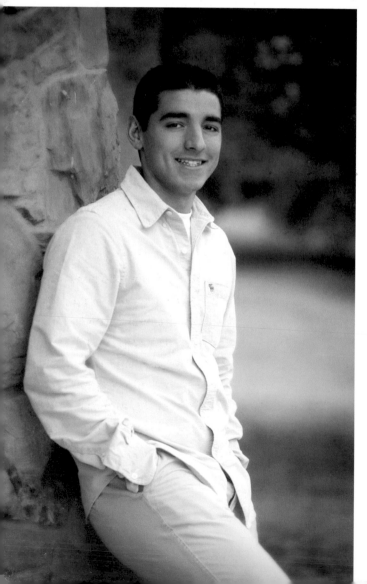

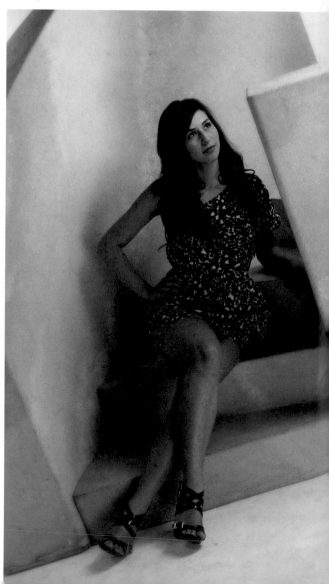

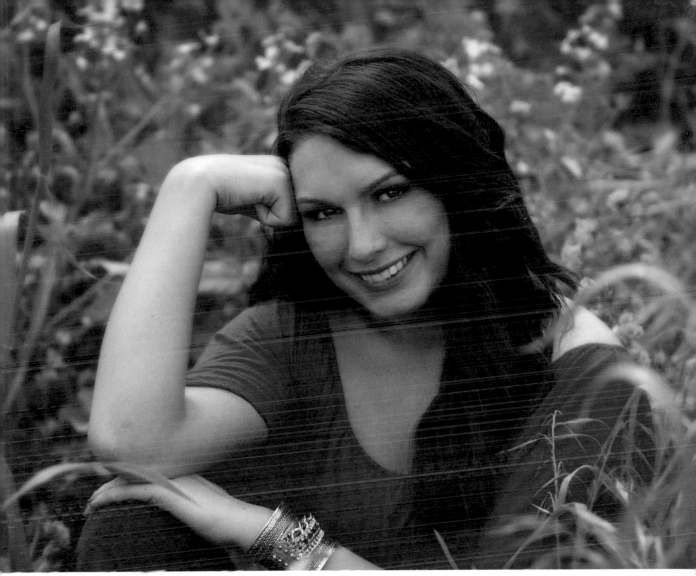

Arms, thighs, and legs can be positioned to create striking lines and curves in the body, adding so much to the final look of the portrait.

CREATE INTEREST

The next step is to pose the body to create more interest within the frame. The lines and curves of the human body can create an artistic look within the frame. The classic "S" curve that a woman's body forms when posed correctly is elegant and beautiful. Arms, thighs, and legs can be positioned to create striking lines and curves in the body, adding so much to the final look of the portrait.

UNDERSTAND THEIR FEELINGS

The last part of posing is understanding the people we photograph. The psychology of posing requires that you understand the human condition. To effectively pose your clients and the sell the resulting portraits you must give your client an image that depicts a version of reality they can live with. You must decide what areas of the client will show in the portrait and hide or disguise the ones they will not want to see.

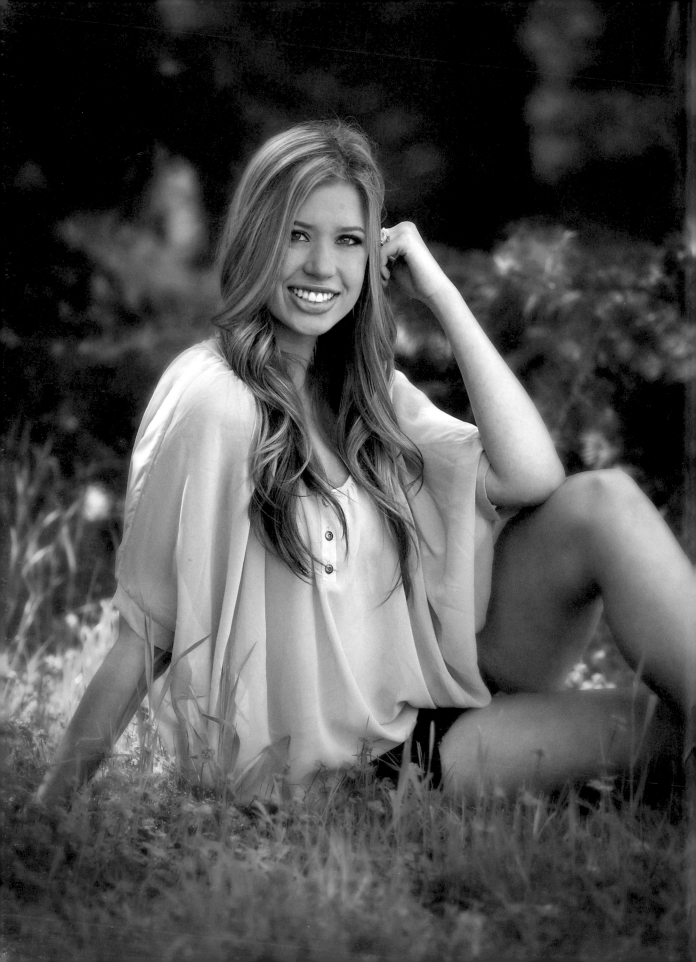

DECIDE WHAT TO SHOW

The process I use to pose all the parts of the body together as an entire pose is simple. I look at the clothing and talk with the client about how much of herself she wants to show. Many times clients realize they have weight issues and request that we do all of their images in a head-and-shoulders composition. If this a client requests this, do it. Don't embarrass a client showing parts of her body she obviously doesn't want to see.

STANDING OR SEATED?

If the subject does want to take a full-length pose, I look at the woman's body type and the way the clothing is lying on her body. While I can do more to hide problem areas in seated poses than standing poses, often the clothing will not allow seated posing.

FIND THE SUPPORT

Once I decide whether the pose will be seated or standing, I determine the base or support of the person: basically where the weight of the body will be supported. In a standing pose it will be the support leg. In a seated pose it will usually be the side of the hip—or the lower legs will be brought up to get the weight off the fleshier parts of the bottom and make it rest more on the tail bone. (See section 36 for more on this.)

WORK FROM THE TOP DOWN

Once the basic position is determined and the weight of the body is properly placed, I start out

TIP ► You have to realize that not every pose will work with every person. If the client looks odd or awkward in the pose you have created, don't waste time capturing images of it, simply re-pose the client. Sometimes it is nothing more than a client's stiffness that makes a pose a bad choice for that particular client. Whatever the reason might be, though, if the client looks less than beautiful, start over.

at the top and work my way down. I check every part of the body and pose it to look its best, following the simple rules we'll be covering in subsequent lessons.

REVIEW AND REFINE

Once every part of the body is perfectly posed, I take a test shot and look for anything that could be improved or that I might have missed.

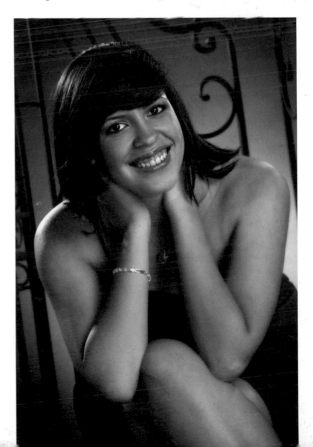

3 SHOW, DON'T TELL

One of the best learning tools for posing is to show poses to clients by posing yourself first. If you can't demonstrate the pose effectively, you can't direct a client into it. Although we have clients select posing and background styles before their session, I always demonstrate several different poses that are variations on the pose they selected.

In my studio, the first thing I have young photographers do is learn the poses. Then, I ask them to start demonstrating the poses to clients. At first, they feel extremely awkward—which is exactly how the client feels. But once they can consistently demonstrate poses and make them-

TIP ► People are often embarrassed by their flaws, but you can make it easier by educating them from the beginning. Let them know that everybody has things in their appearance they would change if they could.

selves look good, they have started to master posing.

After you have demonstrated the pose, watch the client attempt to get into it. Many times, they will not completely repeat what you have shown them, but they will come up with a new variation that is more comfortable for them and that you can add to your pose selections.

It may feel awkward, but the best way to pose clients effectively is to demonstrate the poses yourself.

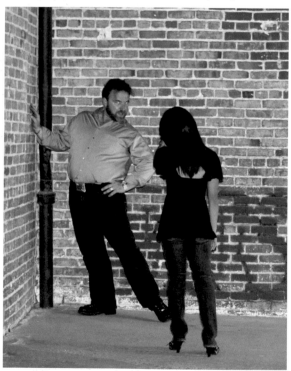 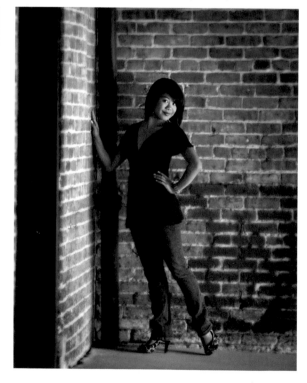

Photographers don't usually spend a lot of time thinking about how to talk with their clients without offending them. Instructions like, "Sit your butt here" and "Stick out your chest" don't make people feel very comfortable with or confident about their chosen photographers.

There are certain words that are unprofessional to use in reference to your clients' bodies. In place of "butt," choose "bottom" or "seat." Never say "crotch"; just tell the client to turn his or her legs in one direction or another so that this area isn't a problem. Instead of "Stick out your chest," say "Arch your back." Replace "Suck in your stomach" with an instruction to "Breathe in just before I take the portrait." To direct a client for a "sexy look," simply have the subject make direct eye contact with the camera, lower her chin, and breathe through her lips so there is slight separation between them.

No matter how clinical you are when you talk about a woman's breasts, if you are of the opposite sex, you will embarrass them. The only time it is necessary to discuss that part of the anatomy is when the pose makes the woman's breasts appear uneven. If this comes up, just explain how to move in order to fix the problem—without telling her exactly what you are fixing. Once in a while, we have a young lady show up for a session wearing a top or dress that is too revealing. If there is way too much of your client showing, you may explain that this dress is a little "low cut" for the type of portraits she is taking.

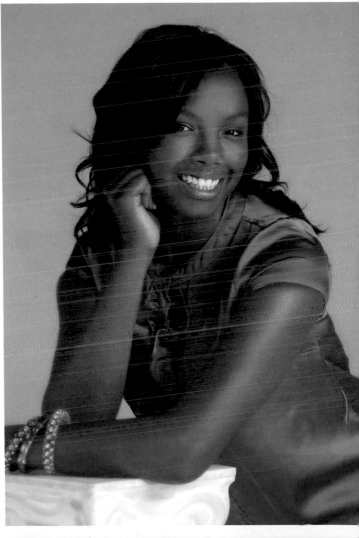

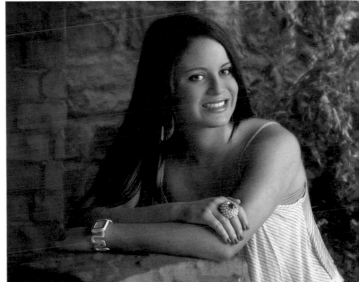

5 USE VARIATIONS

A big challenge is remembering poses when it's time to use them in a session. We have hundreds of samples that each client looks through and selects from. We then write their selections down as a starting place in their session. I then take these ideas as a basic starting point. I then look at their body type, height, and clothing to come up with a pose that is similar, but better suited for that individual. I demonstrate that pose and come up at least three subtle variations that make each pose look similar but unique.

Variations isn't about overwhelming the client with different poses—that just confuses people. However, when subtle changes are made to the original poses, clients can easily select their favorite.

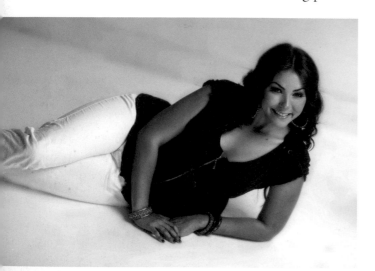

TIP ▶ Look at the poses in this book and think of the variations that you could make. Consider how each part of the body is posed to look its best. Find the areas of the body that were hidden or disguised with the posing, lighting, and scene and which parts of the body were made more noticeable to add to the beauty of the subject in the portrait.

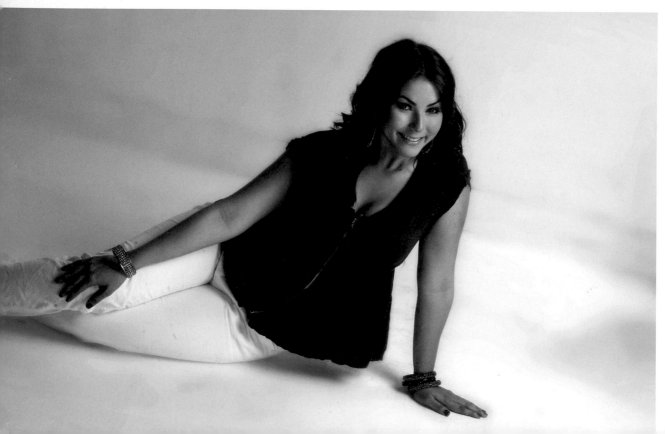

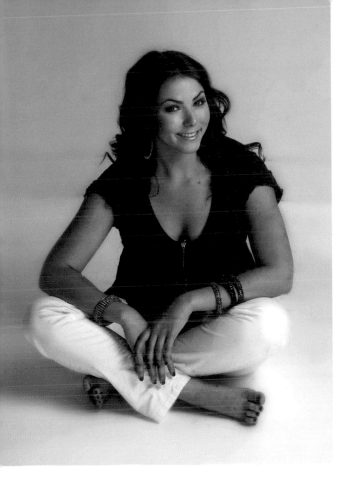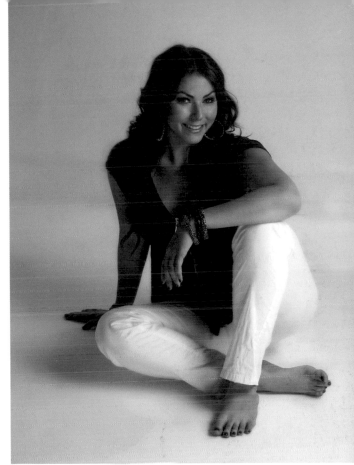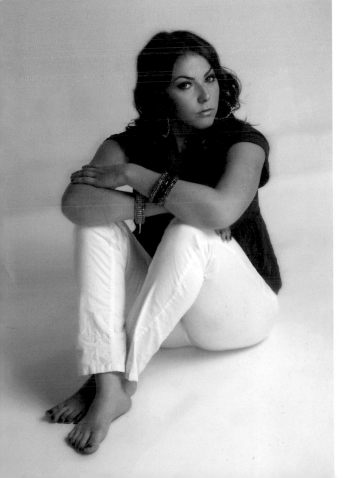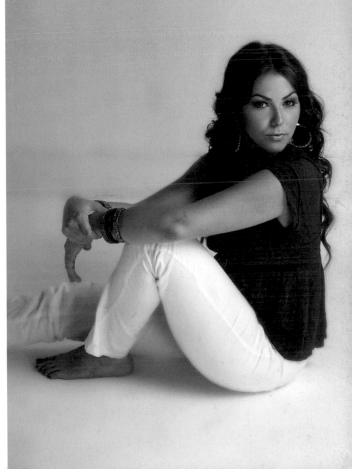

▼

FOR FURTHER STUDY

Examine these images and note how the small posing variations that were used impacted the overall look and feel of the portrait.

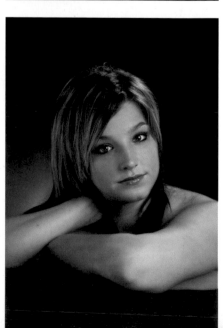

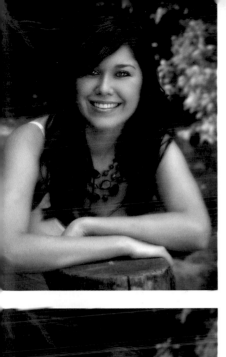
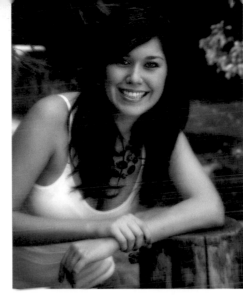
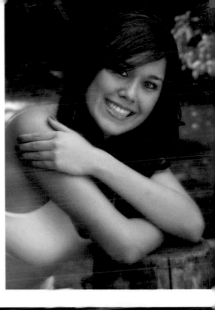
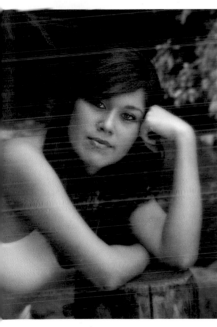
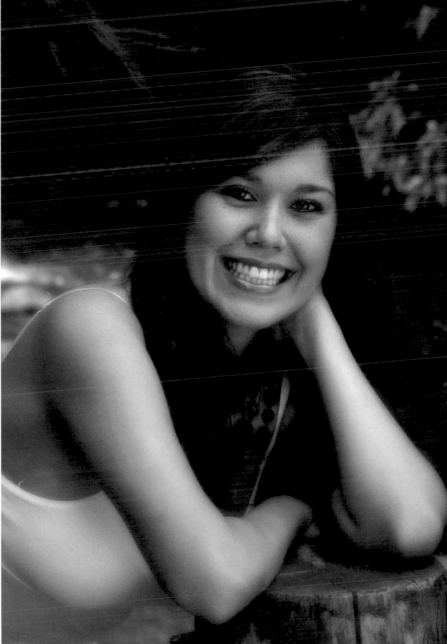
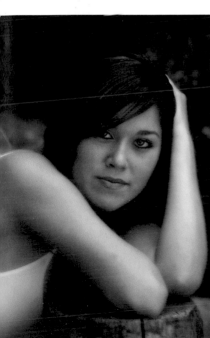

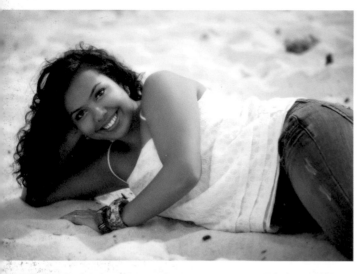

If you want to get beyond basic posing, you will need to identify the reason the client wants the portrait taken.

Imagine that a young woman comes to your studio for a session. All you know is she wants a portrait of herself. Without finding out the purpose of the portrait, you are shooting in the dark. She might want a business portrait, a portrait for her husband, or an image for her grandparents.

Even when the client defines the purpose of the portrait, you should seek all the information you can to ensure you're both on the same page. Let's consider another example: A woman calls you on the phone and says she wants to have a "sexy" portrait taken for her husband for their tenth anniversary. Now, I want you to envision what poses, clothing (or lack of it), and backgrounds you would use to photograph this woman. Do you have the images in your mind? Good. Now, when she gets to the studio, you find out her husband is a minister. Are there any images in your mind that might be appropriate for Pastor Bob? Adjectives like sexy, happy, natural, and wholesome all represent different things to different people. Before you decide how to pose someone, you had better understand what these things mean to them.

I work with high school seniors and there is a huge diversity in taste between seniors and their parents. There are seniors who want to push fashion and good taste as far as the parents and photographer will allow; other seniors are more conservative than their parents.

The poses a young woman might select as portraits for her grandmother (facing page) are probably not the same ones she'd choose for a print she planned to give to her boyfriend (above).

The key is to understand what your client wants *before* you try to give it them—and make sure the looks you create are appropriate for the use and tastes of your client. The posing of a portrait that is to be given to a parent should be much different than a portrait that would be given to a husband or boyfriend. A business portrait would be taken with a different look than a portrait that reflected the person as she is in her "off-duty" hours.

TIP ▶ Before their session, our clients see a consultation video. We used to send this on a DVD, but now we direct them to a secure web site. More people are watching it now—and it only costs us a small hosting fee each month.

7 TRADITIONAL POSING

Once you find out the purpose of the portrait, then you need to select a posing style that will be appropriate.

Traditional posing is used for portraits for business, yearbooks, people of power, and people of distinction. This style of posing reflects power, and to some degree wealth, respect, and a classic elegance. Whether these portraits are taken in a head-and-shoulders or full-length style, the posing is more linear, with only slight changes in the angles of the body.

Whether the client is a judge, a businessperson, or a priest, the posing needs to be subtle. Most of the time, these clients will feel more comfortable in a standing rather than a seated position—mostly because of the clothing they are in. Still, the subject's arms shouldn't rest on the sides of the body. An elbow can rest on a chair or other posing aid, or the hands can be put into the pockets, but not so deep as to have the arms against the sides of the body.

The expressions should be more subtle as well. Laughing smiles are definitely not appropriate. But at the same time, serious expressions need to be relaxed. Most people taking traditional portraits aren't comfortable doing so, and therefore have a tendency to scowl. This needs to be avoided.

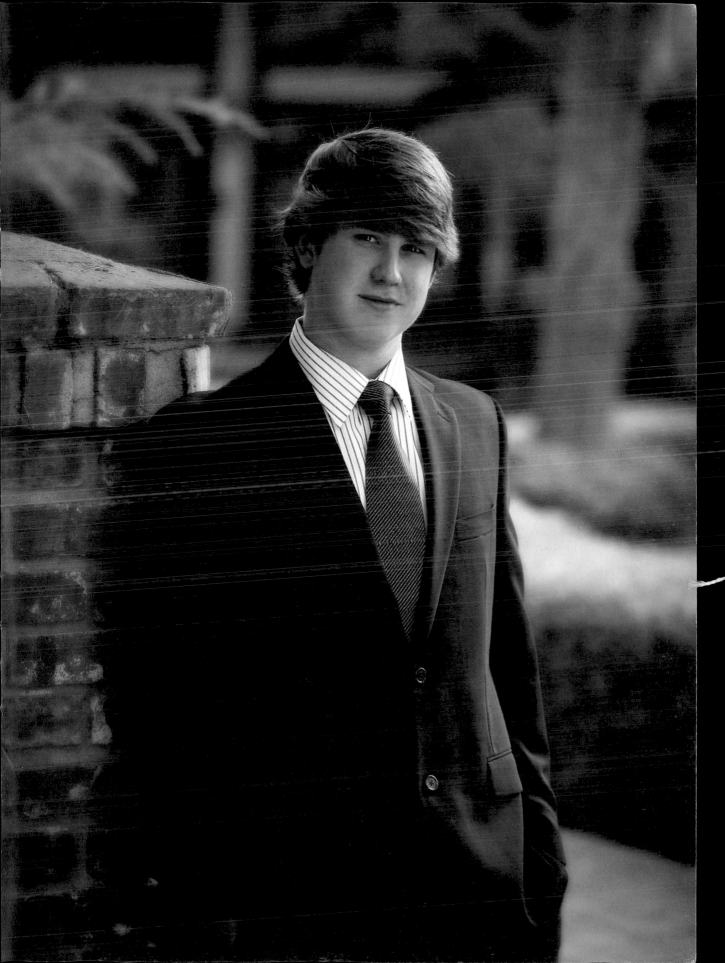

8 CASUAL POSING

Casual posing is a style of posing in which the body is basically positioned as it would be when we are relaxing. Study people as they are watching TV, talking on the phone, or on a picnic and you will see the most natural and best casual poses for your clients. Casual poses are used when the portrait is to be given to a loved one, like a sibling or parent.

Casual poses are resting poses. The arms rest on the legs, the chin rests on the hands. The back is posed at more of an angle. It is common to use the ground to pose on, lying back on the side or even on the stomach. The purpose is to capture people as they really are.

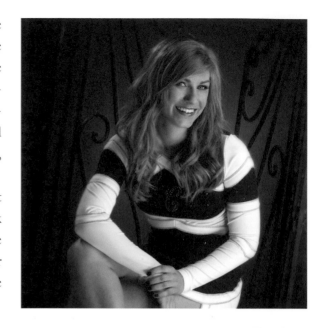

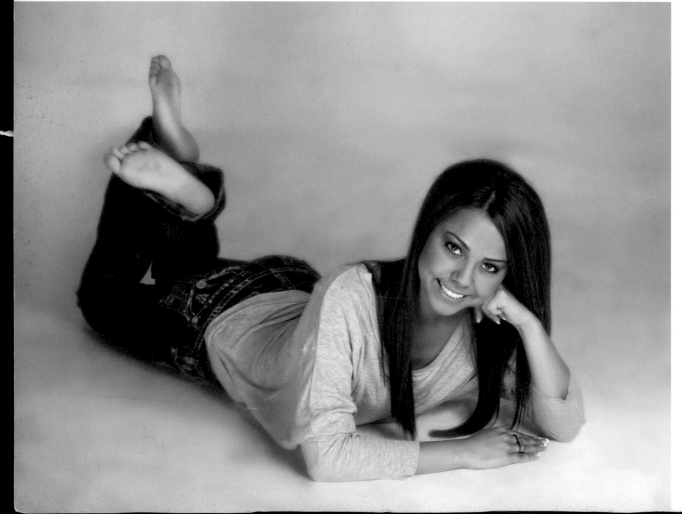

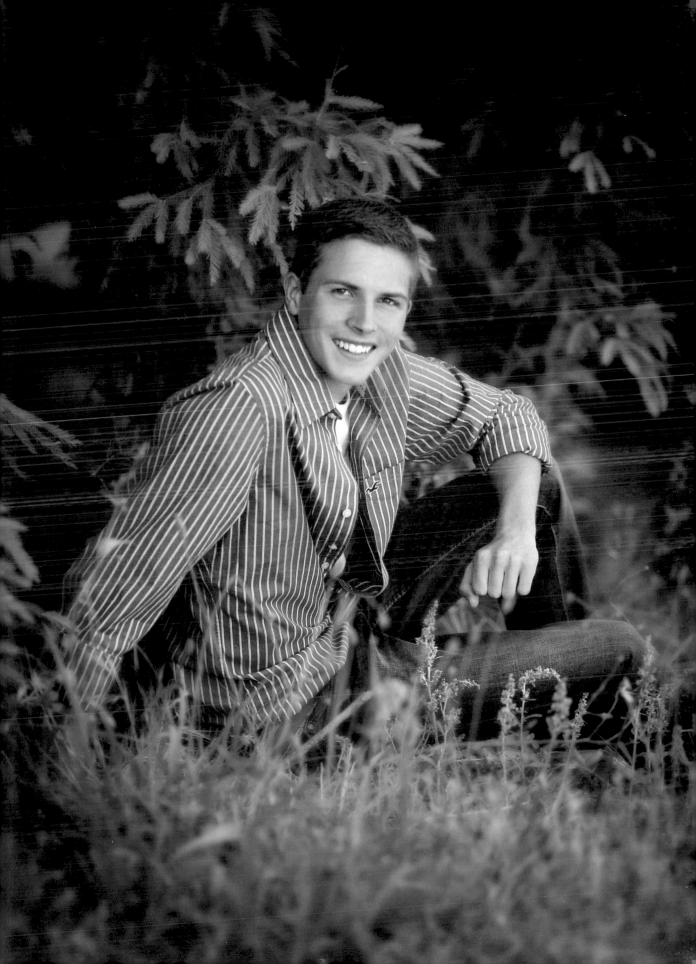

FOR FURTHER STUDY

Casual posing is popular because it feels comfortable and reflects people as they really are— how their friends and family see them every day.

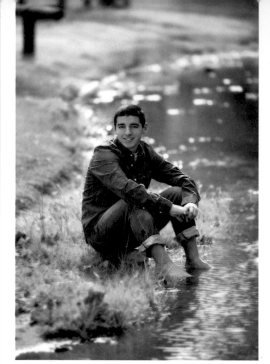

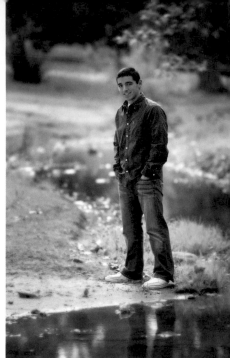

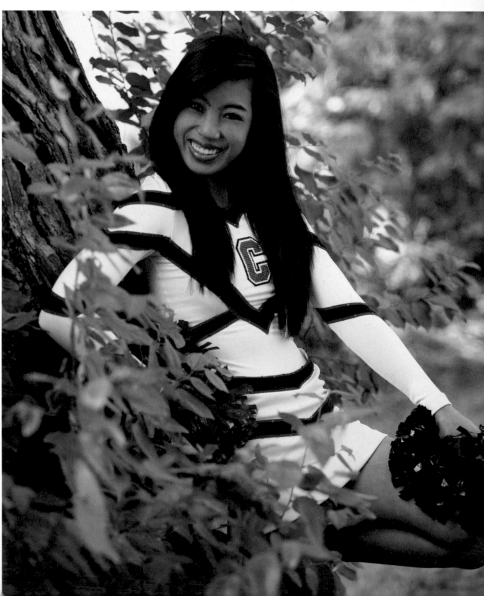

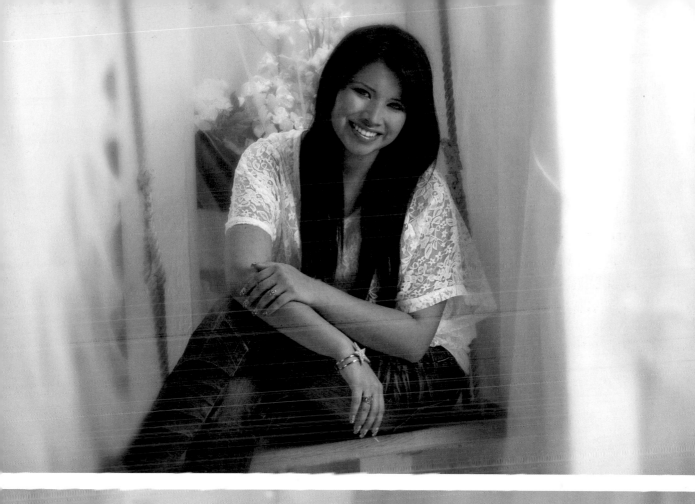
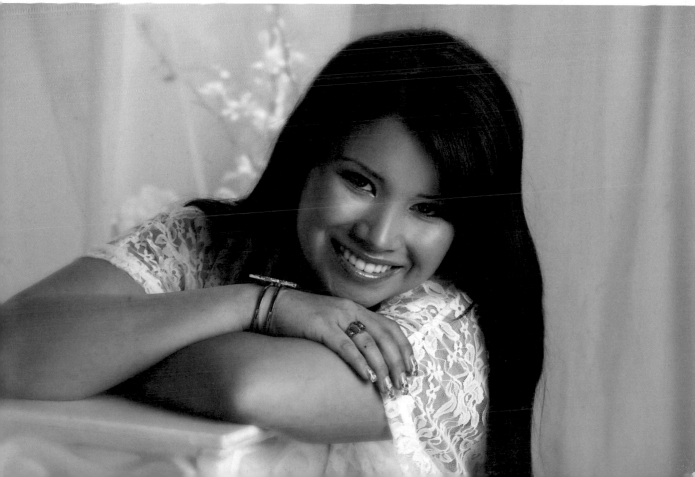

9 GLAMOROUS POSING

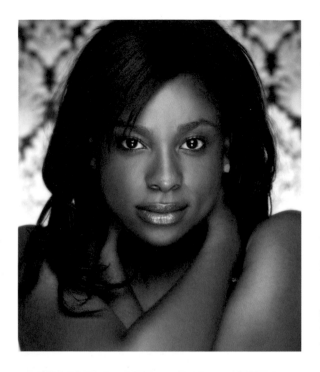

Glamorous posing makes the subject look as appealing and attractive as possible. I am not talking about boudoir or having the client in little or no clothing. You can pose a fully clothed human being in certain ways and make them look extremely glamorous and appealing. If you finish the pose with the right expression, often with the lips slightly parted, you will have made the client's romantic interest very happy.

An excellent source of glamorous posing is found in catalogs such as those published by Victoria's Secret or Frederick's of Hollywood. The photographers who create these images are masters of making the human form look good to the opposite sex. Your client will just have more clothing on.

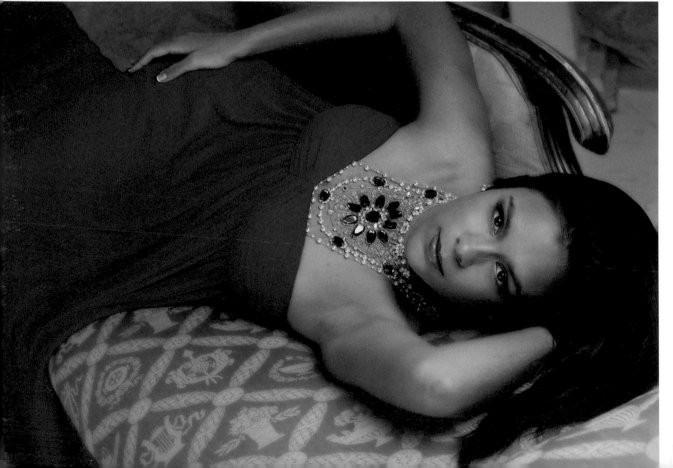

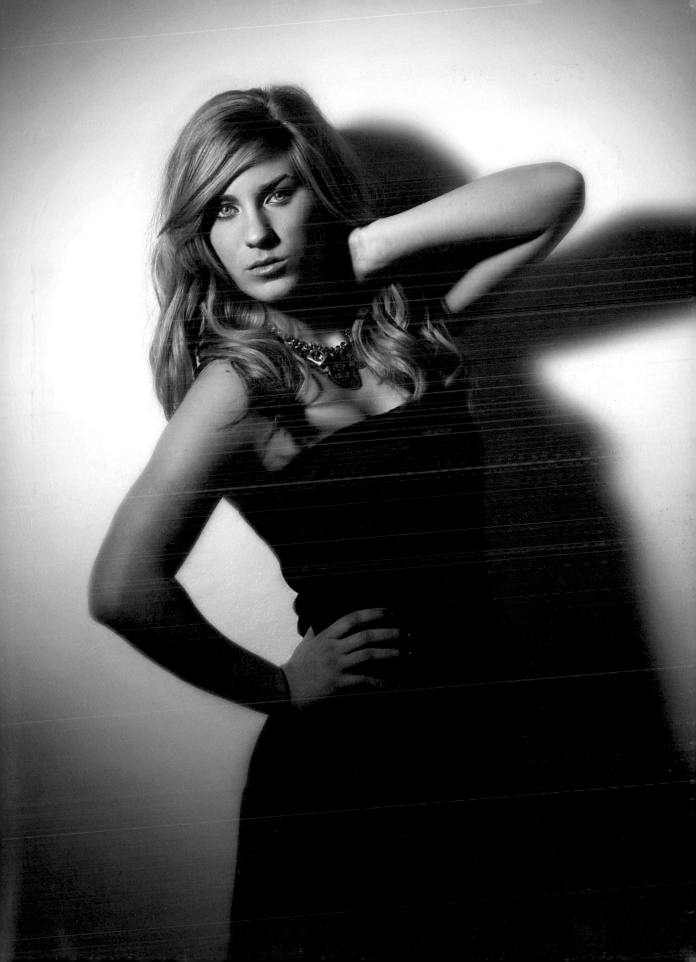

▼

FOR
FURTHER
STUDY

Glamorous posing
shows people
in their most
idealized form—
usually with a
subtle expression
that suits the inten-
sity of the image.

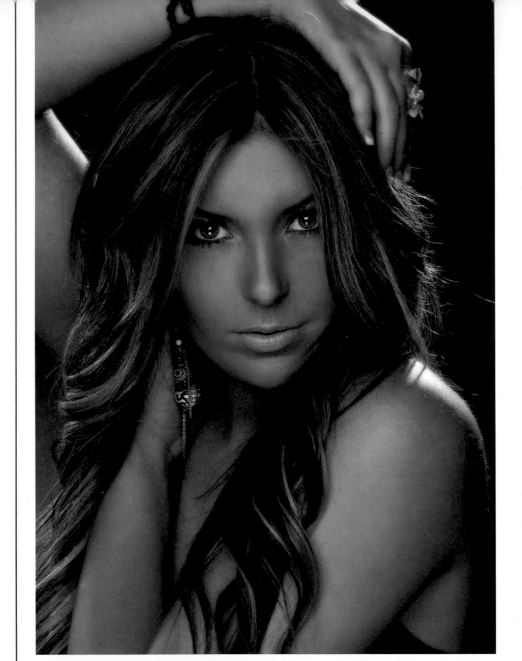

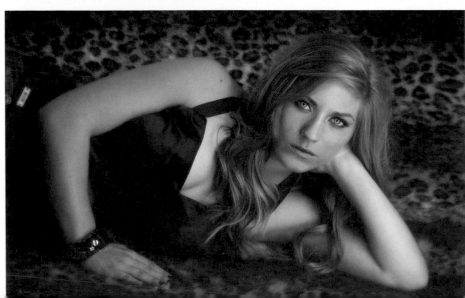

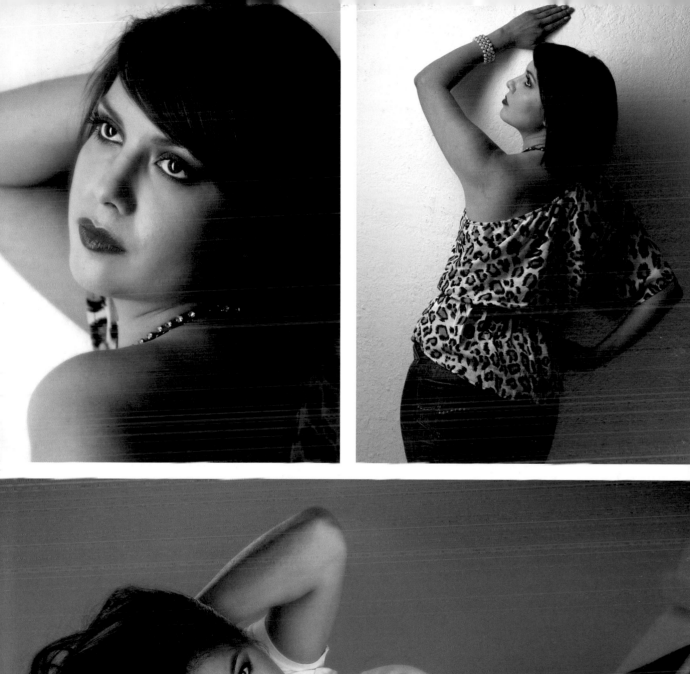
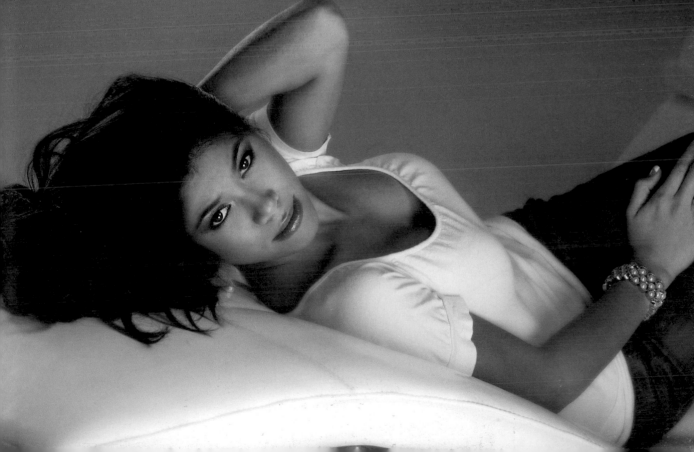

Posing for interest and impact is the next step beyond most posing. In most portrait poses, your goal is to simply to make the client look their best in a pose that seems natural. This creates a portrait in which you really don't notice the posing—it looks as though the client just happened to be sitting there when you pulled out your camera.

Posing for impact and interest, on the other hand, involves drawing attention to the posing style. We can use lighting as an analogy to under-

stand this contrast. For the majority of portraits, you light the subject subtly for a traditional look. If you do your job well when creating portraits

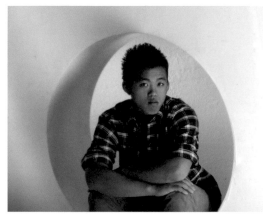

Some poses just seem natural (right); others draw attention to themselves (below).

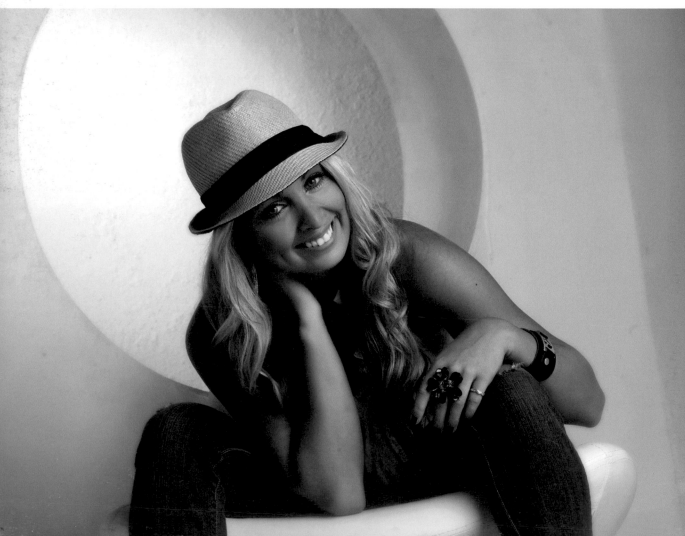

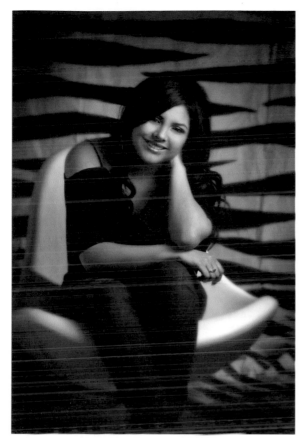

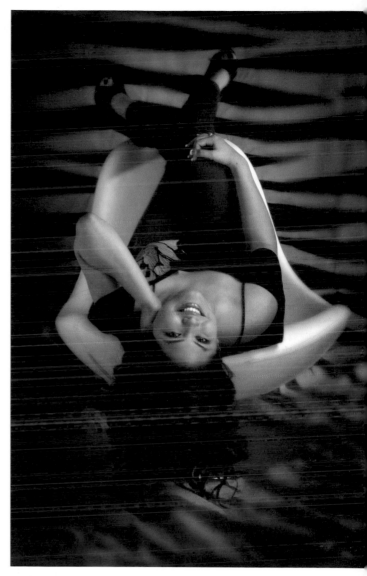

A relaxed pose (above) makes a great portrait for Grandma. The subject herself (or her significant other) might appreciate something with a bit more drama (right).

with this feeling, the viewer really won't particularly notice the light because it looks natural. However, if you switch to lighting your subject with a single spotlight for a more theatrical look, you will draw more more attention to the lighting style itself. For the appropriate subject and portrait purpose, this added impact can be highly desirable and engaging.

The same true as you look at posing. There is posing that is natural and that doesn't draw attention to itself and posing that enhances the overall appeal of the portrait by drawing attention to itself.

TIP ▶ When getting new ideas for poses, look at fashion magazines. These are the images that set the standard of beauty for your clients. Your clients don't want to look like mannequins, they want to look like the models and celebrities on the covers of these publications.

11 CREATE LINES AND CURVES

When posing the human body, there are shapes, lines and forms that create feelings in the viewer.

LINES

Poses with straighter lines convey strength and power. Although these qualities are often associated with masculinity, this doesn't mean you can only use structured poses when photographing men. A structured pose of a woman can convey a sense of strength befitting a professional woman, or an assertive quality that is quite sexy.

CURVES

Poses with curved lines are seen as soft and sensual, alluring for men and captivating to all that view them. Curves visually represent femininity. When you see a winding path in the composition of an outdoor portrait, you immediately visualize a beautiful woman walking down it (okay, maybe that's just me!). As with linear poses, however, curves should not be reserved for one gender. For example, a more curved pose can soften the appearance of a tough-looking dad posed with his newborn child.

Linear poses (left) convey strength, while curvy poses are seen as more soft and alluring (right).

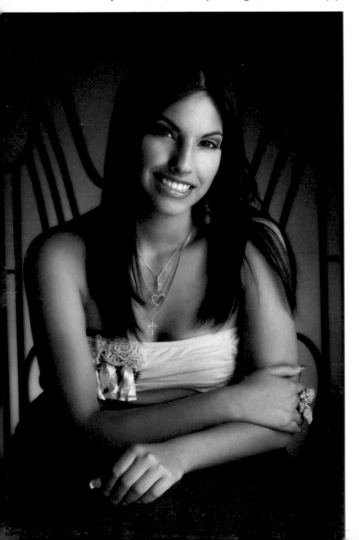
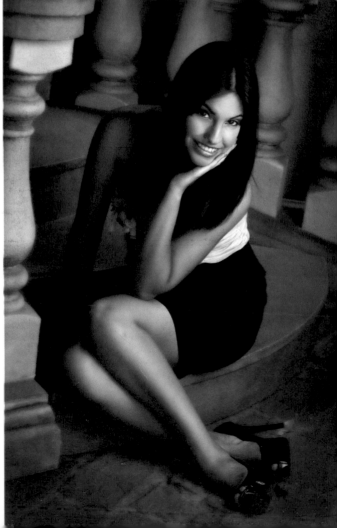

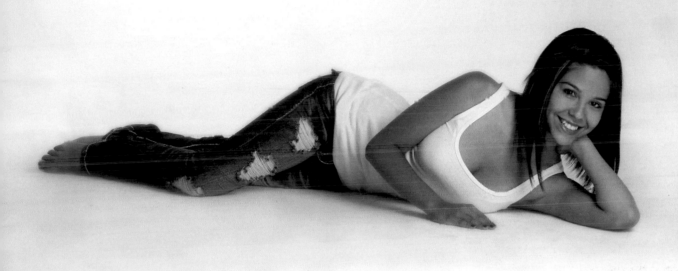

A SIMPLE EXAMPLE

A woman lying on her side could be posed in many ways. Let's say, though, that you want to create a portrait for the love of her life—something that will captivate his attention without being too revealing.

With the body flat on its side it forms a straight line through the frame. Lifting the shoulders up (resting the weight on the elbow) makes the shoulders higher than the waistline, creating a curved line between the shoulders and the waistline. This is a step in the right direction, but let's take it one step further.

The shoulders are now higher than the waistline. For a normal-sized woman, the hip will be higher than the waistline as well. So let's take the upper leg and cross it over, dropping the top knee to the floor in front of the lower leg. This one movement makes the hips and legs appear smaller. It also creates another curved line, with the hip curving downward toward the knee.

You can take this pose one step further and have her rest her head on her arm, creating yet another curved line in the composition and adding more interest to the final portrait.

The final pose adds a great deal more impact to the portrait than just having the subject rest on her side.

The same thing can be done in all poses; you can use the parts of the body to create lines and curves that flatter the subject and add interest. For example, in the tight head shots you see throughout this book, the arms form interesting curves and lines. These not only provide a base for the head to rest on, they contribute to the impact of the pose.

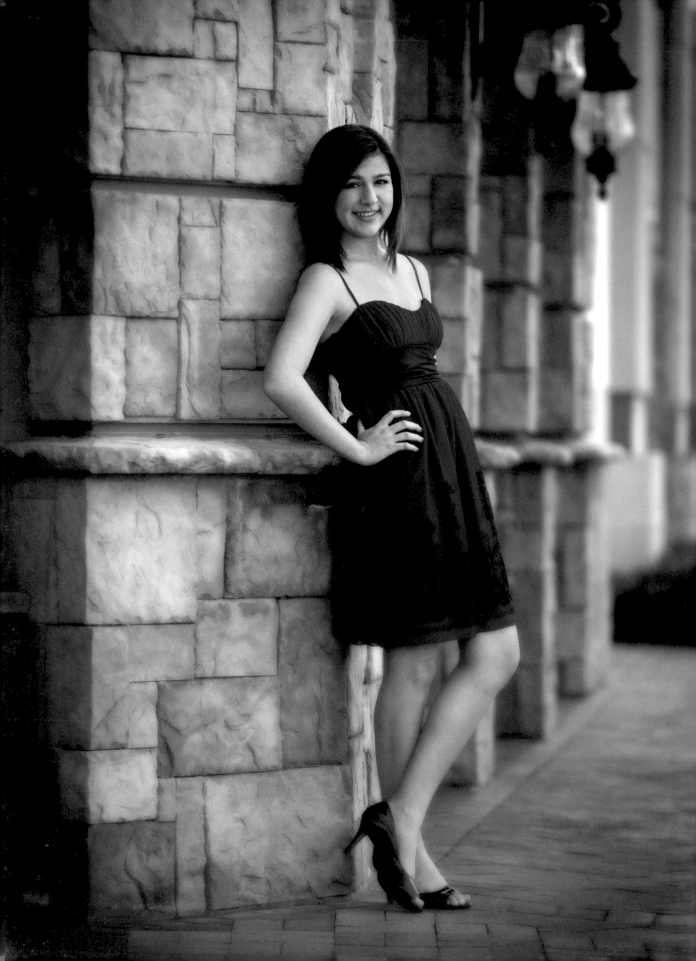

The lines and textures in a background communicate its feeling. Often, this feeling will suggest what kind of pose to use.

A background that has strong, straight lines communicates a sense of structure and strength; backgrounds with curved lines provide a softer, more artistic look. As you begin looking for the feeling that the backgrounds convey, you will start to pick up on the ways the various lines and textures alter the feeling of the background.

TIP ▶ You aren't limited to using backgrounds in one way. You can tilt your camera to make vertical lines more diagonal or open up to soften the texture. These approaches will change the feeling of the background.

Outdoors, a park or beach scene is casual, so casual posing is usually indicated. A setting with columns and fountains is more elegant and suggests more traditionally elegant poses.

A traditional pose (facing page) pairs well with the linear background, while a casual one (bottom left) suits a funky background and chair. Outdoors, a casual pose (bottom right) also makes sense.

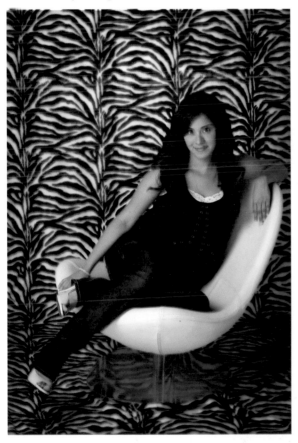
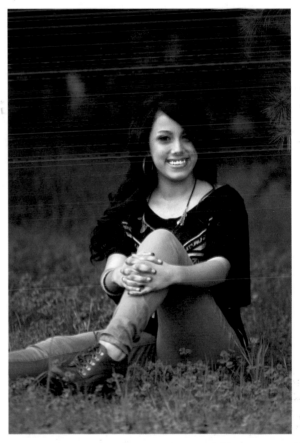

FOR FURTHER STUDY

These columns can be used in many ways—but notice how they lend themselves to more elegant clothes and subtle poses.

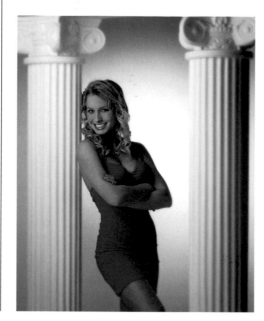

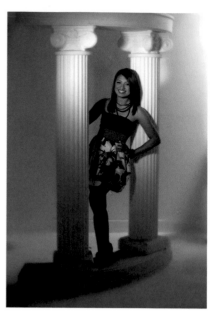

13 CHOOSE THE CLOTHING

You can select the clothing to match the type of posing you want to use, or you can match the posing to the client's choice of clothing. However, you and the client need to realize that the best type of posing is determined by the clothing. When a young lady is wearing a pair of shorts, barefoot, and with a summery top on, it doesn't take a rocket scientist to figure out that casual, slice-of-life posing is called for. When the a girl changes into a prom dress, again, it isn't difficult to know that you should switch to a more glamorous posing style to suit the dress. Of course, you can also decide to use a style of posing that isn't the obvious choice, but you need to make sure that everything in the portrait comes together to make sense visually.

TIP ▶ The desire of our clients to capture the "real" person is the reason why we always have them select the poses and backgrounds that most impress them in our sample books. This way, the client selects what is right for them. We also ask clients to bring in clippings from magazines that show poses they like. These are ideas that are handpicked by our target audience—which is much better than getting ideas from photographers who are trying to fill seats at a seminar (rather than showing the less exciting ideas that actually sell).

Athletic attire (facing page) requires a different style of posing than a strapless evening gown (below).

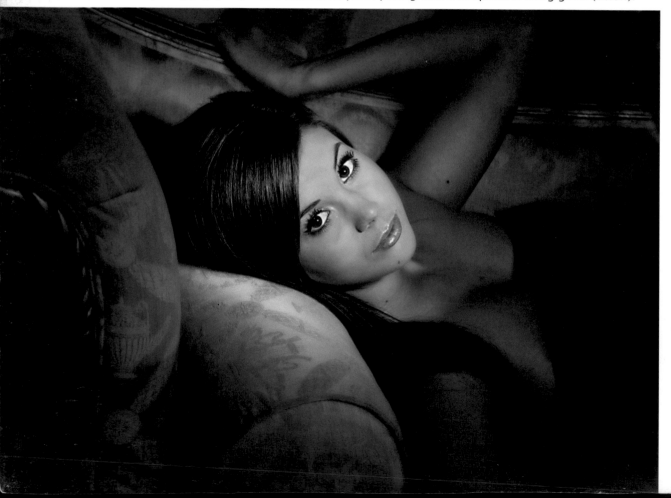

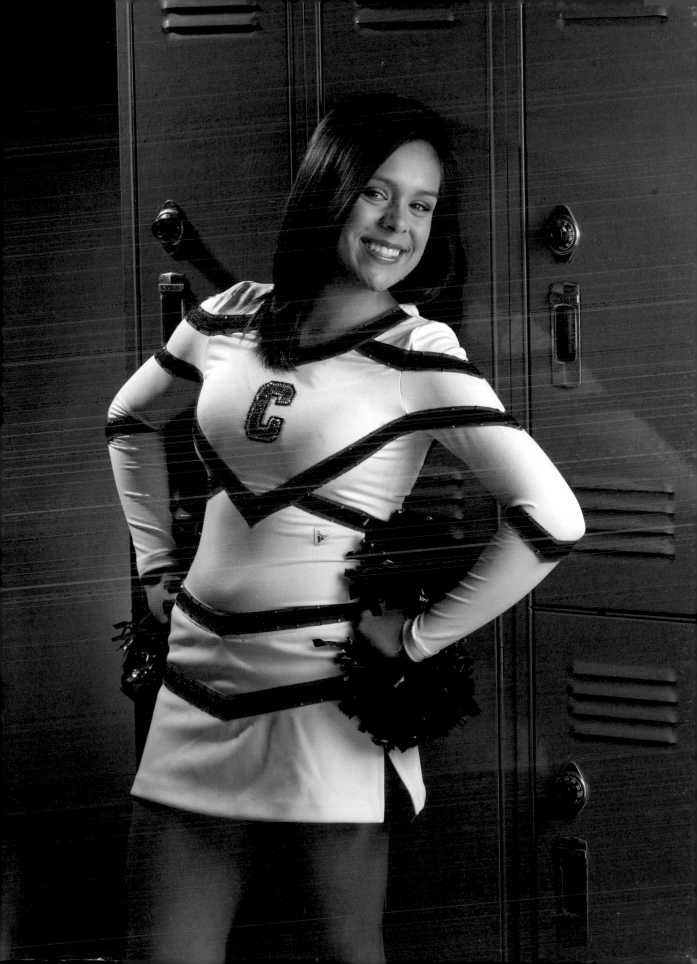

14 CHOOSE THE LIGHTING

Our discussion of posing would be incomplete without considering lighting. Professional lighting typically gives a three-dimensional look to a two-dimensional piece of paper.

THE FACE

I work with a lighting ratio in the 3:1 to 4:1 range. This means if the face is turned away from the main light, the shadow on the side of the nose will increase, making the nose appear larger. There are two solutions: turn the face more toward the main light, or decrease the ratio.

Decreasing the ratio produces a flat look. If, instead, you turn the face toward the main light source, whether in the studio or outdoors, you light the mask of the face without increasing shadowing in areas of the face where it shouldn't be. An added bonus: turning the head also stretches out the neck and reduces the appearance of any double chin.

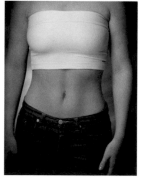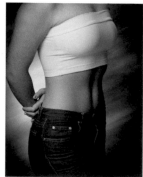

When the hips and shoulders are square to the camera (left), the body looks wide. Turning the body away from the main light (right) is much more flattering to the figure.

THE BODY

Shadowing also gives us a great way to reduce the appearance of body size. My posing theories are based on a simple truth: 97 percent of people never think they look thin enough. With that in mind, my posing styles tends to focus on making people look as thin as possible.

In most poses, I start off with the subject posed with their body in a side view, facing toward the shadow side of the frame. If you look at a subject squared off to the camera and then in a side view, you will immediately see the difference that simple turn makes in the apparent body size.

In the typical pose, the body is posed toward the shadow side of the frame and the face is then turned back toward the main light source. This allows you to control the amount of shadow on the face and it also stretches out any loose skin under the chin/neck area.

Turning the face toward the main light (left) illuminates the mask of the face and creates shadows that shape it nicely. Turning the face away from the main light (right) creates unflattering shadows.

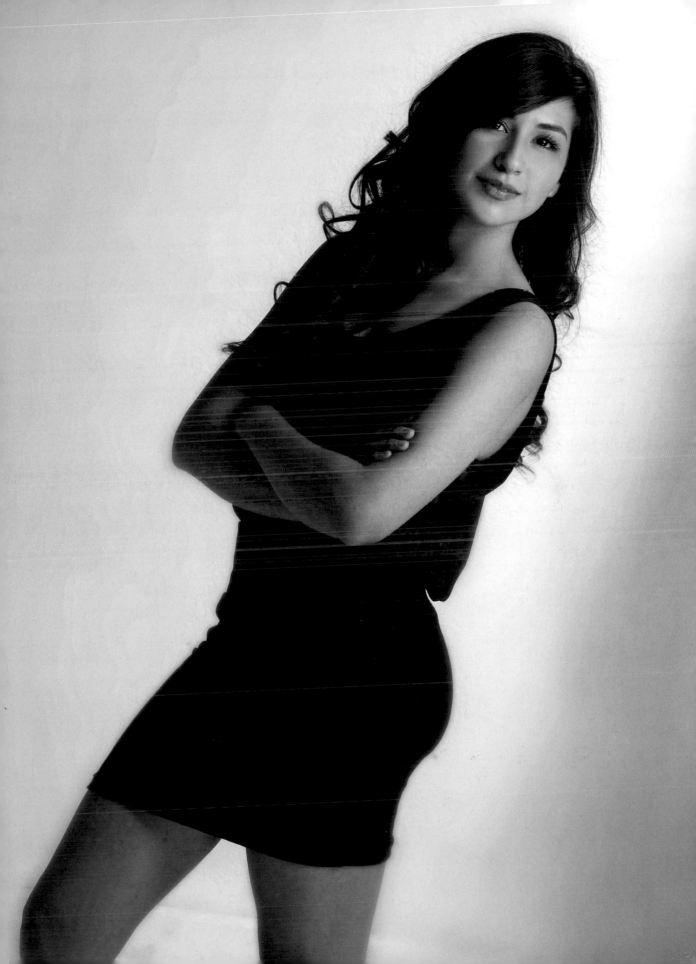

One of the most important decisions we make when posing is how much of the person should show within the frame.

THE PURPOSE OF THE PORTRAIT

The more fashionable the portrait, the more leeway you may have when posing the person. The more conservative the purpose (for business as an example), the more restraint you must use. Understand the expectations of the client and don't treat every shoot as an experiment in creativity.

THE SUBJECT'S APPEARANCE

What should you do when a subject wants to do a pose you know they shouldn't? Situations like this happen more often than most people think.

Fortunately, you can handle it without looking unprofessional or seeing your client turn red. For example, when I see a heavier girl arrive with lots of boxes of shoes, I need to say something. I first explain, "Many ladies buy a matching pair of shoes for every outfit and want them to show in their portraits. But when you order your wallets for family and friends, the full-length poses make it hard to really see your face." (This tells the girl that not all the poses should be done full-length.) I continue, "Most women worry about looking as thin as possible—and worry the most about their hips and thighs. This is why most portraits are done from the waist up." Next I ask, "Now,

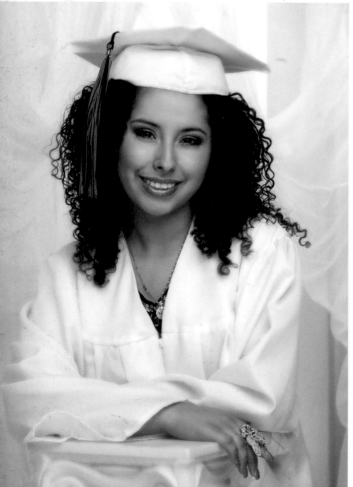

The end use of the portrait (say, for a graduation announcement) may determine the composition.

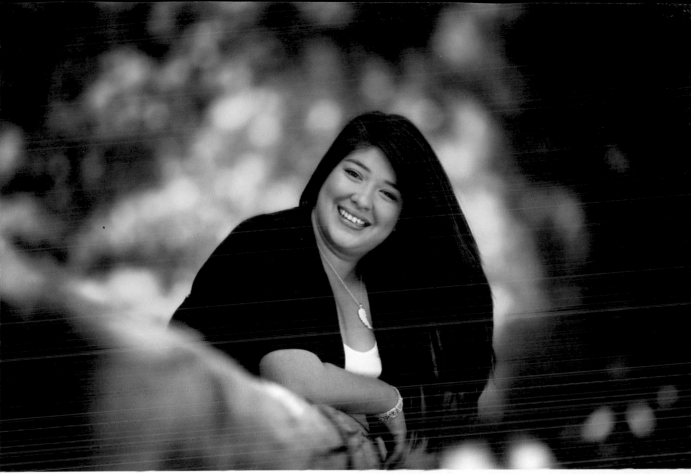

The best way to ensure a woman will feel great about her portraits is not to show any areas of concern. For most women, this includes the hips.

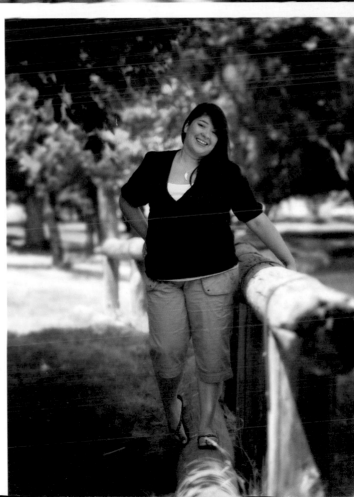

are there any outfits that you want to take full-length, or do you want to do everything from the waist up?" She will usually decide she wants everything from the waist up. This avoids telling her she *can't* take full-lengths, or being brutally honest and telling her she *shouldn't* take them.

Should the girl be really attached to her shoes, I turn to the parent or friend she is with and explain that if we do the portraits full-length, I worry that she won't like them. Once I explain this to the mother, she can tell her daughter not to do full-lengths, or a friend can help enlighten her without causing embarrassment.

COMPOSE THE POSE

A pose must fit comfortably into the composition, meaning it must fill the frame as desired, while not giving the feeling that the composition is crowded. It must also put key focal points in the greatest area of interest.

PLACE THE FACE

Typically you start by deciding the placement of the face. The more traditional the use of the portrait will be, the more centered or symmetrical the placement of the face. The more fashionable the style of portrait, the more asymmetrical the placement of the face typically will be. This isn't always the case—you might place a business person off-center to showcase something in the background or foreground that is important, or you might center the face in a more fashionable portrait—but these are creative choices that should be made by you and your client.

THE RULE OF THIRDS

The rule of thirds is a good starting place for understanding where to place the face. When you divide the frame of the image in thirds both vertically and horizontally, the areas where the lines intersect are visually the strongest points in the composition. For all but the most traditional portraits, placing the face along one of these lines or at one of the intersection points is a safe bet.

The subject's face is placed at one of the rule-of-thirds lines and her body fills out the rest of the horizontal space in the frame, completing the composition.

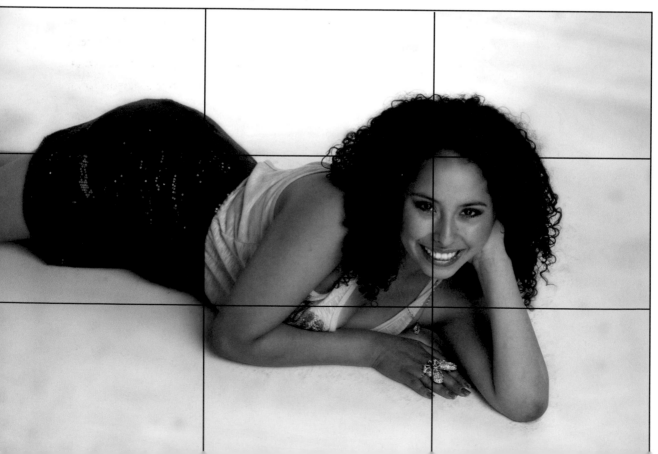

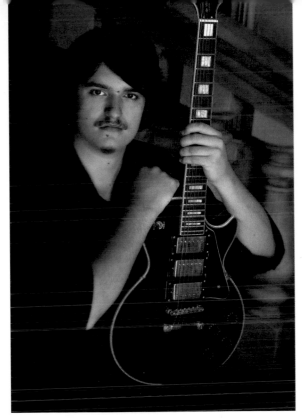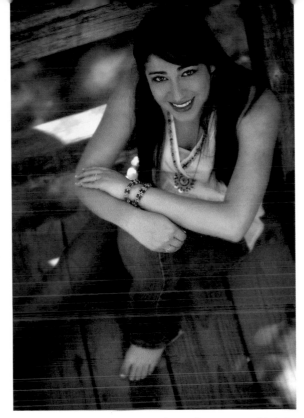

After placing the face, fill the rest of the frame with the body or other elements. Tilting the camera (right) can help fit the pose/subject into the frame in a pleasing way.

FILL THE FRAME

After you place the face, you can pose the body to fill the remaining space. For a bridal couple posed in one third of the frame, a long train is natural filler for the rest of the frame. A girl posed in a horizontal composition with her face in one third of the frame might have her torso and legs to the side to fill the rest of the frame and to bring balance to the image. The placement of the face and body (or persons, props, scene elements, etc.) within the rest of the frame should lead your eye through the frame to the face.

ANGLE AND CAMERA TILT

In addition to understanding the placement of the subject within the frame, you must also consider the camera angle and tilt of the camera when working with a pose. Often, when I am working with a single subject, I pose the client for impact and then change the camera angle and tilt to fit that pose/subject into the frame. I find it is usually easier to move the camera to an unusual angle than it is to move a person to an unusual angle.

TIP ► The balance of the pose within the composition comes from planning your pose to fit within the frame you are creating. If you don't plan the pose to fit the composition, you can (and will) create portraits that lack balance and a fluid movement of the viewer's eye.

FOR FURTHER STUDY

Large props, like cars and motor-cycles, can provide an almost infinite variety of posing options—and good foreground elements to conceal any problem areas.

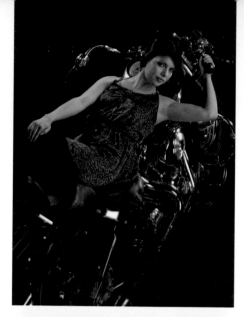

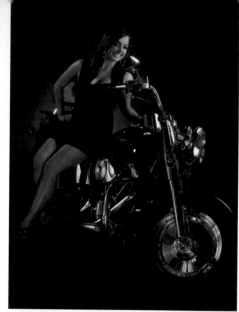

FOR FURTHER STUDY

When shooting with large props, think outside the box. Try posing your subject in the foreground or the background. Look for ways to place your subject in a different perspective in relation to the prop.

CROP THE POSE

While composition is very important, cropping—deciding where the bottom of the frame will be—is a critical part of posing.

The Portrait Length

Once you decide on whether an image will be a head shot, head-and-shoulders, waist-up, three-quarter-length, or full-length composition, you can pose the subject to form a base for the area where the frame will end. Putting the arms up and the hands through the hair forms a natural cropping point for a head shot. Having the el-

bows away from the body fills the sides of the frame and provides a cropping point for a head-and-shoulders portrait. A knee extended forms a good cropping point for a three-quarter-length pose. Basically, you are completing a triangular composition.

Unusual Cropping

Cropping doesn't have to be traditional. For instance, it is perfectly fine to pose a portrait that doesn't show the top of the head. However, if you don't balance the pose within the composi-

At the bottom edge of the frame, the body is posed to create a triangle with the face at its peak.

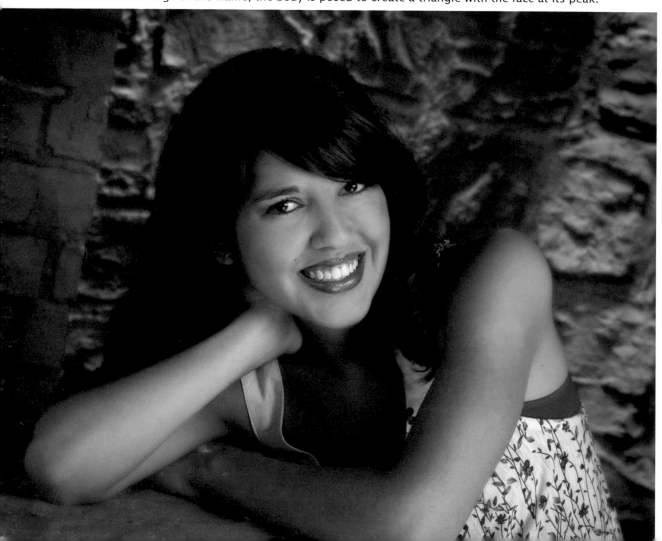

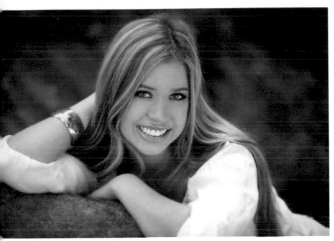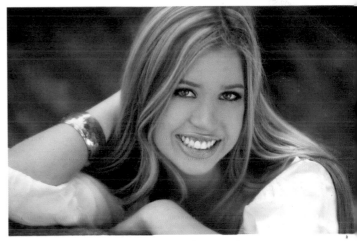

When I crop off the top of the head, the pose is designed for such cropping. Notice how, despite the tighter view, the eyes remain positioned according to the rule of thirds.

tion, it will look you made an amateur mistake. When I crop of the top of the head, the pose is designed for such cropping. In a head shot, this means keeping the eyes at the upper one-third of the frame. As the camera moves closer, eventually the top of the head will be cropped. If you get even closer, the bottom of the chin will not be in the frame. But if you keep the eye in the right place, the composition will remain appealing.

MULTIPLE OPTIONS

Many poses let you choose from different ways to compose the portrait. Poses like these work very well in high-volume photography studios. Once the subject (in this case, let's say it's a senior) is in the pose, a full length or three-quarter pose is done so she can see her entire outfit. Then a close-up is done to make Mom happy. Both are taken without having to re-pose the subject.

Poses that offer multiple cropping options work well in high-volume studios, giving the client more ordering options without a lot of re-posing required.

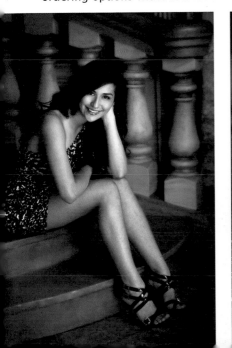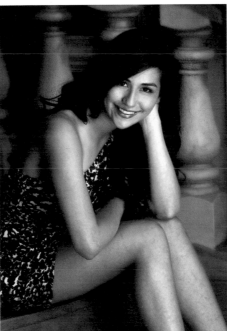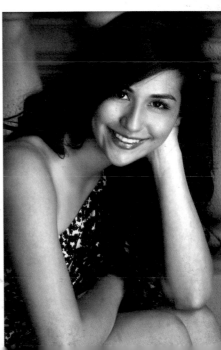

PLANNING IS CRITICAL

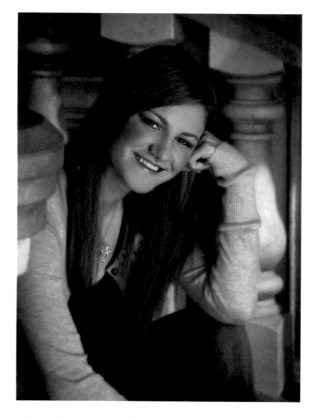

As you have probably guessed by now, the key to posing for flawless cropping and composition is planning and forethought.

PLANNING PROTECTS YOUR BOTTOM LINE

We all have been fascinated watching fashion photographers shooting with professional models—going from pose to pose almost effortlessly. However, our clients aren't professional models and we're not fashion photographers. Accordingly, our shooting styles have to be different.

Fashion photographers shoot hundreds or thousands of shots to get the perfect image their client is looking for. They are also compensated for the expenses involved in doing that. Portrait photographers, on the other hand, are not paid the expense of shooting countless images. For us,

this fashion style of shooting is counterproductive—and it's a sword that cuts twice. First, you have the time involved in taking, downloading, and storing all those images. Second, you must edit down all the images to a viewable number for the client.

As portrait photographers, we must shoot *less* to produce a profitable session. At the same time, we must work with the average public—people who know nothing about posing themselves and definitely don't look like professional models. While it seems like we get the short end of the stick, it is just requires a different process to get to the same end: a beautiful image.

TIP ► In the profession of photography, the so-called "journalistic" style has caused some confusion when it comes to posing. If you are going to pose someone, you must take control of the look and determine the way that person is to be posed. Hoping for the best isn't posing. Even if you decide you want an unposed look, doing *nothing* isn't an option; some direction is going to have to be given. I see a lot of young photographers who neither pose the client nor involve them in anything that would record some aspect of their life in their imagery. Telling a client, "Hey, stand over there" is neither posing nor a "journalistic" approach. It's just hoping for the best—and praying that the client doesn't notice you have no idea what you're doing.

BE CLIENT-FOCUSED

Portrait photographers have to be client-focused. If you are a fashion photographer and the model thinks her butt looks big in the shot the client selected, who cares? If you're a portrait photographer and your subject thinks her butt looks big . . . you have a problem.

When we learn photography, we all start off shooting like fashion photographers. It is fun and exciting. Then, as we start working with paying clients, we get frustrated because our process has to change. Suddenly, we need to plan the way we are composing and cropping the image based on the client's wishes and the clothing selected. We need to design poses that make the client look amazing while giving the portrait a professional look. This doesn't all come together while you are shooting on the fly.

To be successful—to please our clients and sell our work—we need to make a conscious effort to do all our planning before we ever touch a camera. There is something about a camera in the hands of a photographer; we tend to quit thinking and planning and start wanting to shoot. Unfortunately, this "throw it against the wall and see what sticks" theory of posing, cropping, and composition doesn't work, folks!

A QUICK REVIEW

Let's review. The first step is posing is talking with the client to see what type of portrait the client wants you to create. Second, you must help the client select the best clothing to create that type of portrait. Once the clothing is selected, you can determine the cropping and composition. Finally, you can design a pose that will make the subject look amazing.

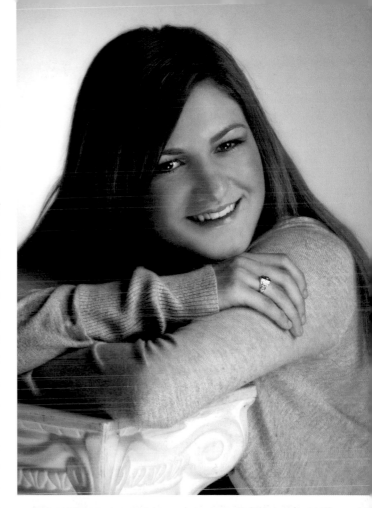

▼

FOR FURTHER STUDY

Don't leave posing aids out of your portrait-planning process. Having a chair handy can assist you in designing flattering, comfortable poses that clients will adore.

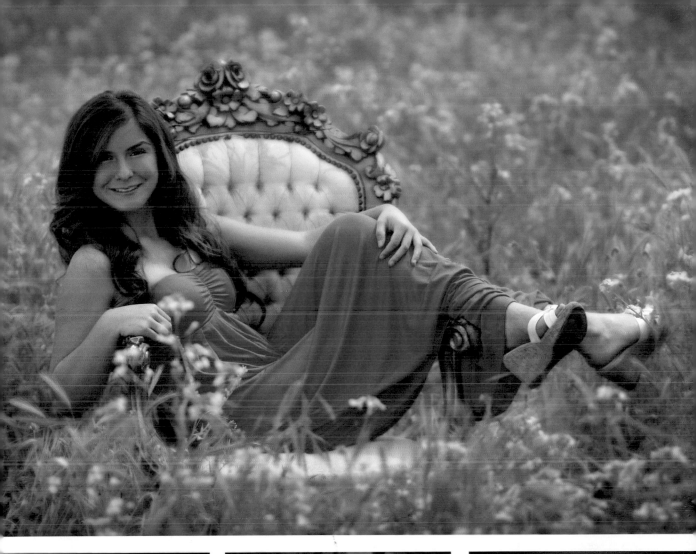

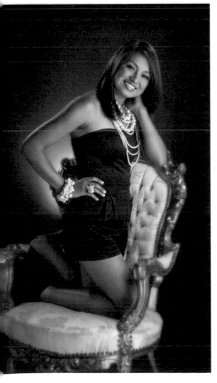
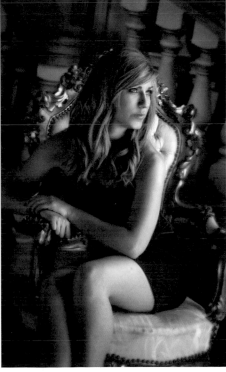
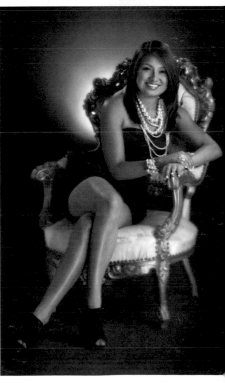

The face is the most important part of a portrait. However, the face has many parts—and sometimes it feels like they are all working against each other. For example, imagine you are photographing a person with a large nose and a wide face. To make the face appear thinner, you could increase the shadowing on the side. Unfortunately, the harder light or reduced fill will deepen the shadow on the side of the nose, making it appear larger.

IDENTIFY PROBLEMS

It is pretty easy to assess a person's face and see if there are problems. If you look at a person and think "Wow, what a nose!", that might be a problem you should address. For most people, however, their face is their soul. If you mess with it too much, they won't look like themselves; you don't want to mess around with someone's soul.

FRAME THE FACE

When the shoulders are not going to be in the frame, the face needs to be supported to look its best. (There is little worse than the "floating head" look!) You can bring the hands to the neck or cheek to create a base for the face to visually rest on. This correction can also help conceal a common problem area: the neck and chin.

CONSIDER THE TYPE OF POSE

Your approach to posing the face will also depend on the style of portrait you are creating. In

In traditional poses (left), the neck alone supports the face. In casual poses, the hands or arms are often used to support the face (right).

Lifting the hands or arms frames the face for an appealing look.

traditional poses, the face is positioned with only the neck for support. Casual poses capture people the way they really are when they are relaxed, so the head will often rest on the hands, arms, or shoulders. Glamour poses are posed for a sensual feel, so the shoulder will be raised toward the chin (also slimming the view of the shoulder) or the hands may be lifted to the neck, face, or hair.

THE CONNECTION TO LIGHTING

The posing of the face is linked to lighting. Posing that will work with soft lighting and a low lighting ratio will look ridiculous with a harder light source or a high lighting ratio. For traditional portrait lighting styles, or spot lighting, you would have the face turned more toward the main light for impact. Using butterfly or ring lighting, you would have the face looking directly at the camera. With most Americans being overweight, it's often a good thing to make the face appear thinner than it really is. For these subjects, the best view of the face is when the body is turned toward the shadow side of the frame and the face is turned back toward the main light source. This stretches out everything from the shoulder up and gives the face a leaner look.

FOR FURTHER STUDY

Most portrait buyers are looking for a great view of the subject's face—so don't make the mistake of capturing only longer views. Headshots should be the majority of your captures. Add the arms or hands into these closer portraits for added variety.

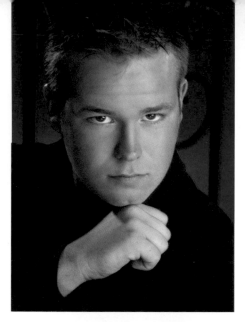
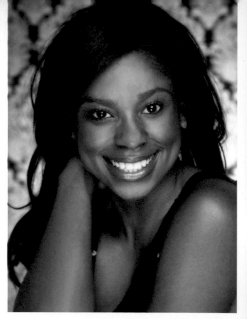
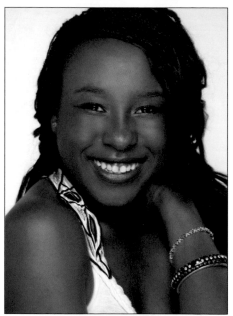
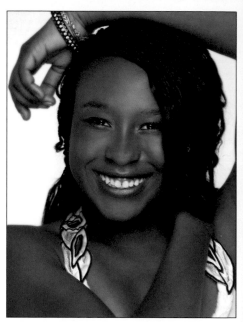

The "Rules"

According to the traditional rules, a woman is always supposed to tilt her head toward her higher shoulder. Conversely, a man should always tilt his head toward his lower shoulder. The *real* rule is that there is no rule. You don't *always* do anything in photography. You don't tilt toward the high shoulder and you don't tilt toward the low shoulder, you tilt toward the shoulder that makes the subject look good.

The best approach is to pose the body, then turn the face to achieve the right lighting. Now stop. If the person looks great (80 percent of clients do), take the image. If the subject is uncomfortable and starts tilting their head in an awkward direction, correct it. It's that simple.

Don't Go Too Far

If you overdo the tilt, you'll create a "broken neck" look. No one will notice if you don't tilt the head, but everyone will notice if you tilt it too far. Some fashion photos show extreme head tilts, but these are things you should practice in sample sessions before offering them to clients.

Hair

When photographing a woman with long hair, I look to the hair and not the gender to decide

Subtly tilting the head changes the look of the portrait and the subject.

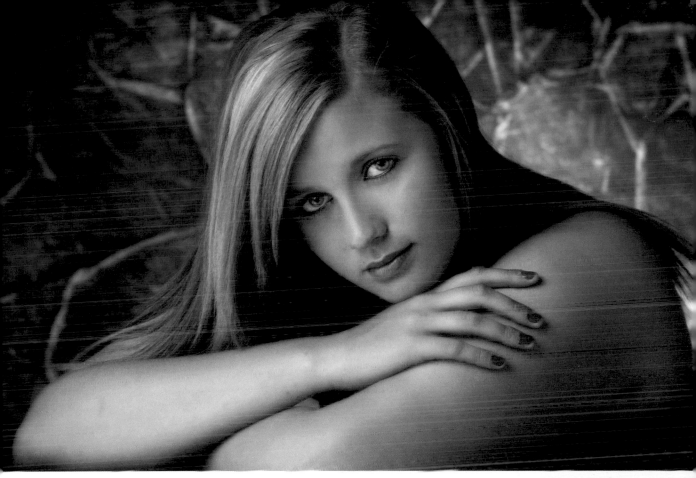

For women with long hair, tilting toward the fuller side of the hair gives it a space to fall into (above). For guys, a traditional tilt or no tilt at all usually produces the most flattering look (right).

the direction the head will be tilted. The tilt will go to the fuller side of the hair and the pose will create a void on the same side for it to drape into. This means she will sometimes be tilting toward the lower shoulder.

Guys

Guys typically aren't gender benders; they usually need the classic tilt or no tilt at all. But again, the pose and the circumstance dictate the direction the head is tilted or whether it is tilted at all.

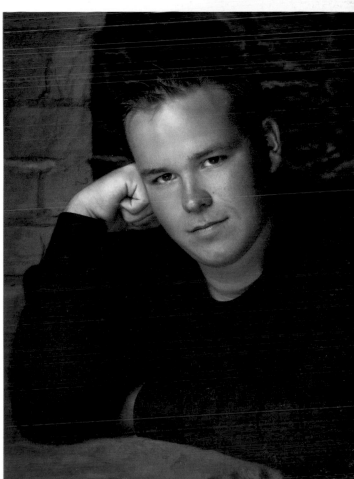

WATCH THE CATCHLIGHTS

Most photographers don't think about pos-
ing the eyes. However, the eyes are the
single most important part of any portrait. If you
don't take the time to make sure they are beauti-
ful, you reduce the beauty of your client, the ap-
peal of the portraits, and how salable the images
will be.

It is particularly the catchlights that give the
eyes life. They attract the viewer to the eyes and
are one of the primary goals of any professional
photographer. The appearance of the catchlights
is determined by the placement of the main light.

The main light creates catchlights that make the
eyes sparkle.

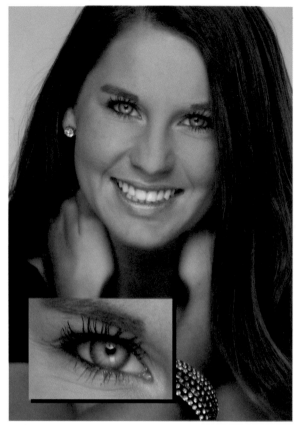

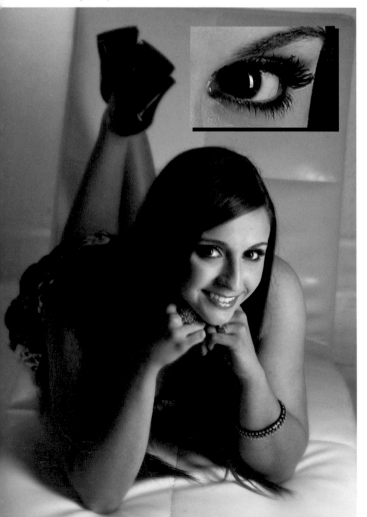

Light from underneath the subject adds an addi-
tional catchlight and brings out the eye color.

To make the correct placement easier to de-
termine, I suggest raising your chosen main light
to a point that is obviously too high, then slowly
lowering the light until the eyes are properly lit
with a nice catchlight.

Because I favor more of a glamour/fashion
look, I also like to have a light come from be-
neath the subject's face. This adds an additional
catchlight in the eyes, brings out more of the eye
color, reduces the darkness under the eyes that
most people have, and smooths the complexion.

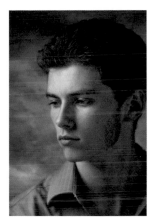 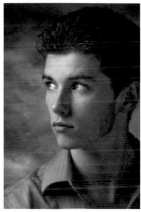 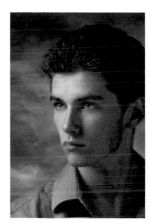 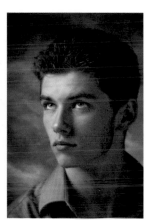

Changing the direction of the subject's gaze dramatically alters the feel of a portrait—and sometimes not in flattering ways.

There are two ways to control the position of the eyes. First, you can change the pose of the eyes by turning the subject's face. Second, you can have the subject change the direction of their eyes to look higher, lower, or to one side of the camera.

Typically, the center of the eye is positioned toward the corner of the eye opening. This en-larges the appearance of the eye and gives the eye more impact. This is achieved by turning the face toward the main light while the eyes come back toward the camera. This works well for all shapes of eyes, except for people with bulging eyes. When this is done on bulging eyes, too much of the white will show and draw attention to the problem.

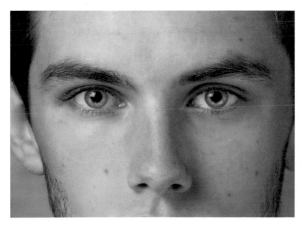 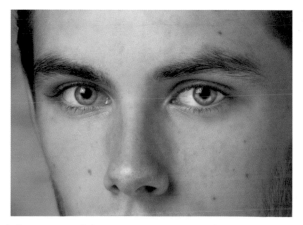

Positioning the iris (the colored part of the eye) toward the corner of the eye opening gives the eye more impact.

EYE CONTACT

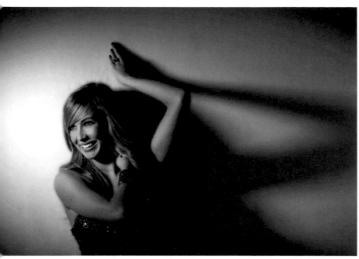

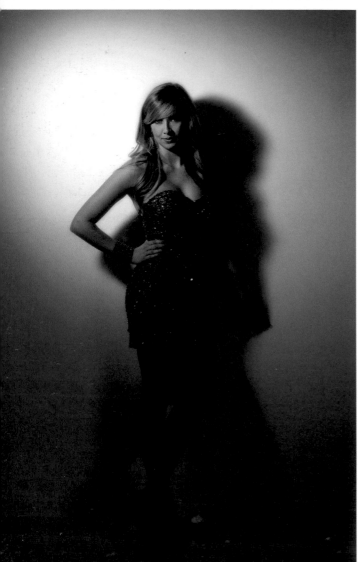

The point at which you ask the subject to focus their gaze in respect to the position of the camera's lens also, in essence, poses the eye.

LOOKING AT SOMEONE

First and foremost, the subject should always be looking at someone, not something. There is a certain spark that the eyes have when they look into another person's eyes that they lack when they are looking at a spot on the wall or a camera lens. To do this, I put my face where I want their eyes to be—usually directly over the camera. This puts the eyes in a slightly upward position, increasing the appearance of the catchlights. If the camera position is too high to make this possible, I position my face on the main-light side of the camera, never beneath it and never to the shadow side of it.

EYE CONTACT VS. REFLECTIVE POSES

When the eyes of the subject look into the lens (or very close to it), the portrait seems to make eye contact with the viewer. This type of portrait typically sells better than portraits that have the subject looking off-camera in a more reflective pose. Reflective posing does, however, work in a storytelling portrait—a bride glancing out a window as if waiting for her groom, a senior glancing over the top of a book and thinking of the future, new parents looking down at their baby, etc. In order please everyone, you should be able to offer both styles of posing.

SEMI-PROFILES

Unless your client's face has the perfect shape that makes a profile salable (most don't), a semi-profile, where both eyes are showing, is preferable for portraits with a reflective look. When doing so, the nose should not extend past the line of the cheek behind it.

SHOW ONE EYE OR TWO

As you turn the face away from the camera, there comes a point where the bridge of the nose starts to obscure the eye farthest from the camera. At this point, you have gone too far. You must either go into a complete profile, showing only one eye, or bring the face back to a semi-profile, providing a clear view of both eyes.

LIGHTING

Your main light should remain at a consistent angle to the subject as they turn toward the profile position. If you normally work with the main light at a 45- to 50-degree angle to the subject's nose, it should stay at that same angle relative to the nose as you rotate the face away from the camera. This keeps the lighting consistent and doesn't destroy the shadowing on the face.

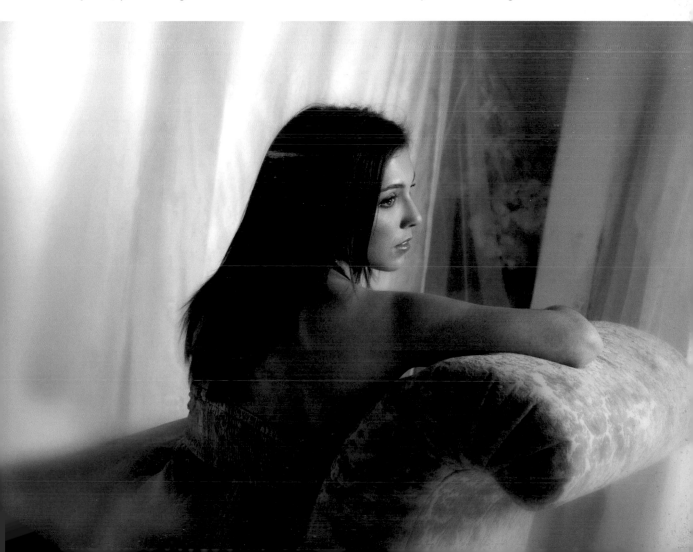

25 THE NOSE

The nose is not my favorite part of the body (especially since mine is on the large side—an affliction I share with many men). The two controls you have over the nose are the highlight on the top of the nose and the shadow created by the side of the nose. How big the nose looks will be determined by the size of the shadow the nose produces. To reduce a larger nose, turn the face more toward the main light source in traditional lighting or raise the intensity on the lower light/reflector for butterfly-style lighting.

In these two portraits of a beautiful young woman, you can see how much different the nose looks when you move the main light from a butterfly position (left) to a greater angle (right). If your subject would benefit from less emphasis on the nose, opting for butterfly lighting would clearly be a choice to consider.

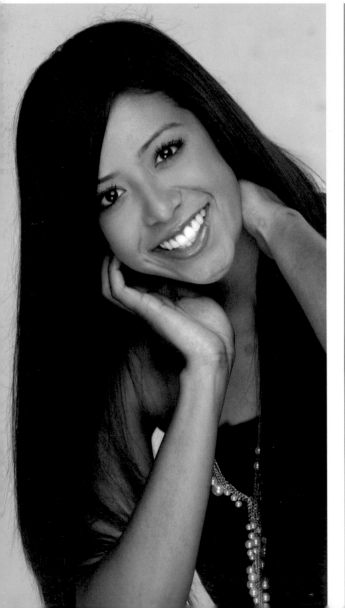

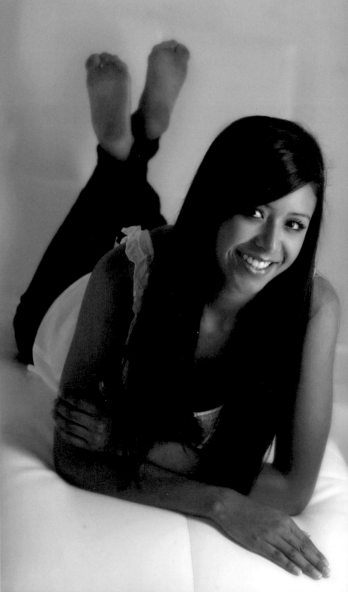

When the subject is looking directly at the camera, the ears are more prominent (left). Turning the face to an angle and providing less tonal separation reduces the visibility of the ears (right).

Ears seem to be of two types: either you don't notice them at all or they are glaringly obvious. Women with average ears might show them; women with larger or protruding ears tend to use their hair to cover them up. With short-haired men, however, even ears that look like they could fly away with the owner will be right out there for everyone to see. Men will also have no problem showing oddly shaped ears—right up until they see them in a portrait, that is.

To reduce the prominence of large ears, turn the subject's face toward the main light source to hide one ear and prevent the outline of the ear showing on the side of the head. Reducing the fill will reduce how noticeable the visible ear is, hiding its size in shadow. When only one ear is the problem, simply hide it behind the face on the main light side. While you can use Photoshop to rectify ear problems, these corrections are time-consuming and much better to deal with in the camera room.

Like the eyes, the mouth and lips tell the story of the person you are photographing. A smile reflects happiness; as a result, smiling photographs consistently outsell non-smiling photo-

graphs. I typically take ten shots of each pose; six to seven are smiling and the other the three to four are not.

Timing

Timing is also important with expression. I want clients to have smiles that range from laughing smiles to smaller grins and everything between. The difference between a laughing smile and small smile is a matter of a second or less, so you must practice your timing to know when to capture the image to get the expression you want.

TIP ▶ Before I start photographing anyone, I tell them, "Your smile looks best when you are out with your friends and they say something funny. Because you are not thinking about your smile, it looks completely natural. The minute someone thinks about smiling, they try to control it. Whether that's you worrying about having the perfect smile or your mother turning into the 'smiling cheerleader,' if you think about it, it won't look natural." (This warns mothers about making the subject feel self-conscious). I continue, "Just look at me and even if you burst out laughing, stay in the pose and let me capture your smile when it looks best." Finally, I add, "Later, we will do some expressions that are not smiling—but I didn't say serious! When some people hear me say 'Relax your smile,' all the life leaves their face and they press their lips together. The only time that people who know you see you with your lips pressed together is when you are upset—so they will say you look mad in all those poses. Just relax your expression and take a breath through your lips."

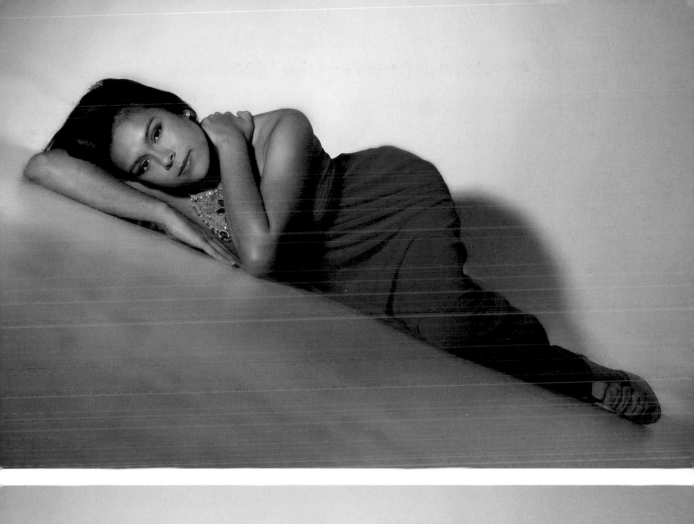
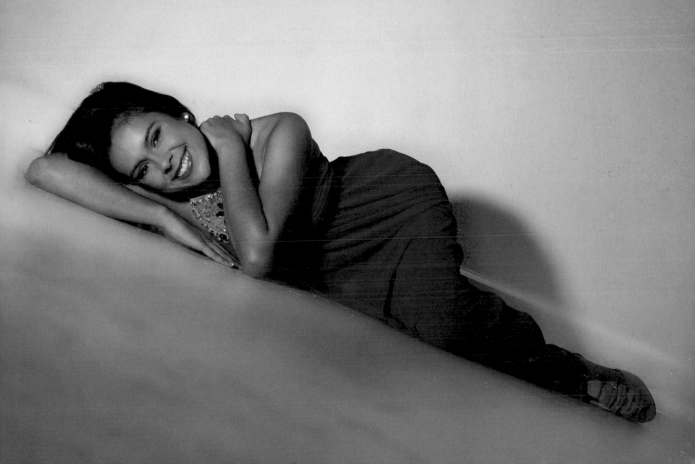

▼

FOR FURTHER STUDY

Expressions sell portraits—and natural smiles sell better than more serious expressions. Learning how to elicit and capture them is a big part of your job as a professional photographer.

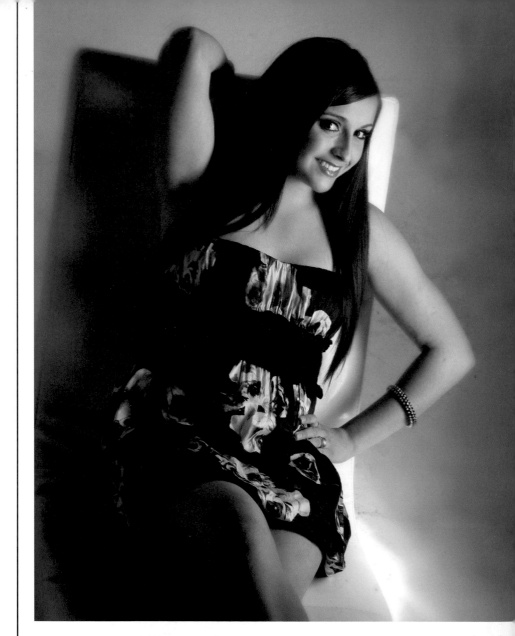

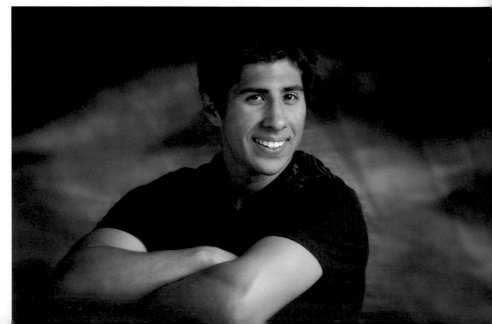

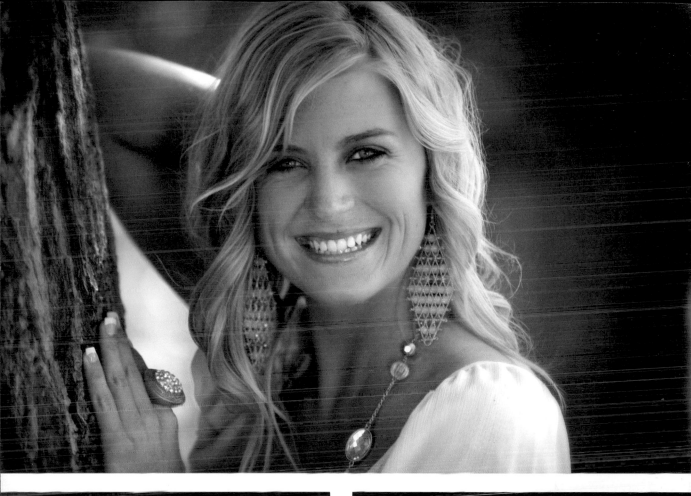

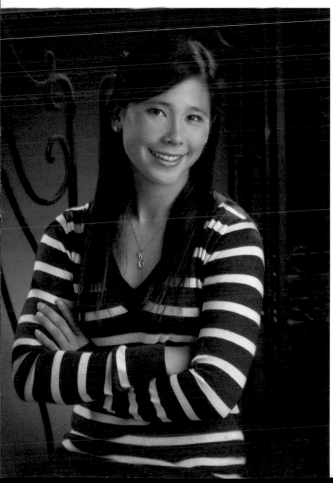

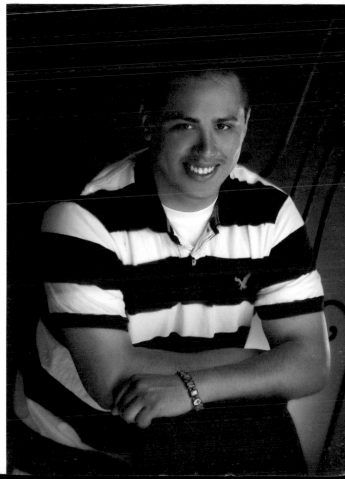

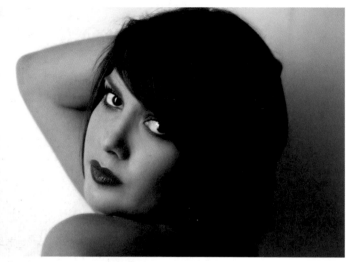

The neck really isn't posed and it really isn't part of the face, but there are a few points that should be shared about this area. First of all, the neck is the first area of the body to show weight gain and age. Because this is such a concern for most clients, especially women, you will notice that a great many of my portraits hide this area from view.

CONCEAL THE AREA

A high-neck sweater is one option, but a problematic neck or double chin can easily be hidden by having your subject rest their chin on their hands, arms, or shoulders. For a more glamorous look, have the subject raise the shoulder closer to the camera toward her chin.

TRY THE TURKEY-NECK POSE

If the subject has a major problem in the neck/chin area, you may need to resort to the "turkey neck" pose. To do this, have the subject extend their chin toward the camera (to stretch out the double chin) and then bring the entire face down to further hide the neck area. The turkey neck is effective for reducing the size of a double chin, but it can also hide the bulge that appears (particularly with heavier gentlemen) when the shirt collar is a bit too snug.

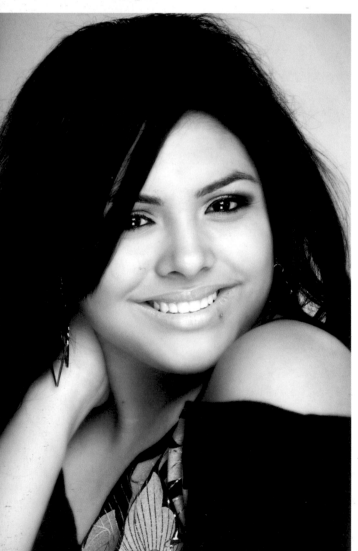

Lifting the shoulder makes these portraits look more glamorous, but it also helps conceal the neck and chin—which can be a problem area for so many portrait subjects.

Stretching the chin forward, as seen below, effectively reduces the appearance of a double chin and is not obvious from the camera position.

▼
FOR FURTHER STUDY

Lifting the hands or arms can conceal the neck/chin area. Happily, this technique also presents almost limitless opportunities for designing more inventive and personalized poses.

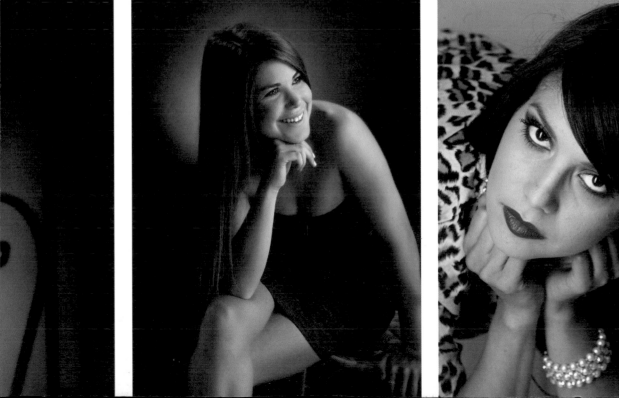

CREATE A DIAGONAL

A client's shoulders create an important line in most poses—and it shouldn't be a horizontal line. Designing the pose so that the shoulders create a diagonal line makes the portrait more interesting and makes the subject look less rigid.

CLOTHING

It is always a good idea to have the shoulders covered with clothing if the subject's weight is at all an issue. Clothing itself, however, can create problems. For instance, large shoulder pads will make just about any kind of posing impossible—and make your client look like a football player. An even bigger problem is ladies' clothing or undergarments that cut into the skin on the shoulders. The resulting indentations visually translate into "she's fat." Another problem is the grooves that can be left on the shoulders from a woman's bra. If this could be a problem, have a female staff member ask her to take her straps down early in the session to reduce the marks on her shoulders by the end of the session.

MEN VS. WOMEN

In general, the shoulders of a man should appear broad and at less of an angle than the shoulders of a woman.

Men generally want their shoulders to appear broad; women want their shoulders to look slimmer.

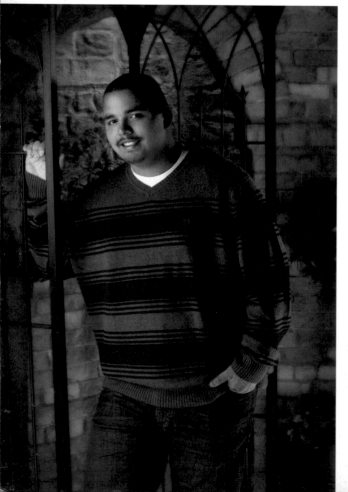
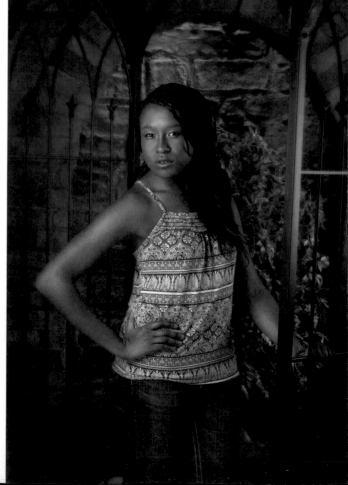

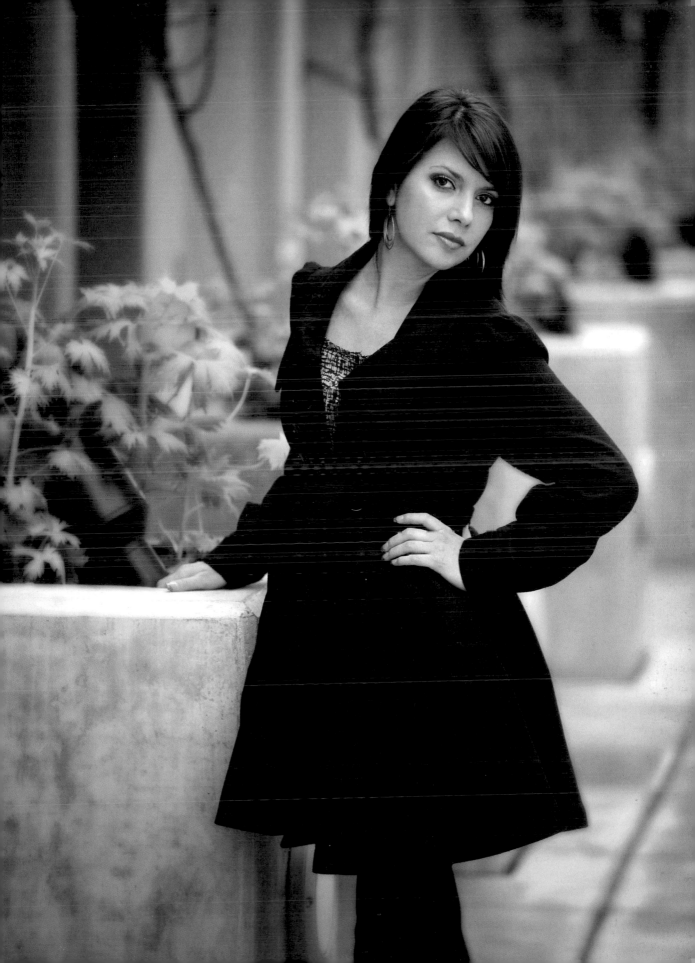

SUGGEST LONG SLEEVES

Models may have perfect arms, but our clients are plagued with a variety of problems—arms that are too large or too bony, loose skin, hair appearing in embarrassing places, stretch marks, bruises, veins, etc. Therefore, we suggest that everyone wear long sleeves.

EXPLAIN PROBLEMS WITH TACT

If you see that your client is a larger woman who has brought sleeveless tops, explain, "One area women tend to worry about is their arms looking heavy—that's why we suggest long sleeves. Now, you can try one sleeveless top, but most women stick to long sleeves just to be safe." This is a nice way of telling your client, without embarrassing her, that her arms are too large for that kind of top. Referring to *other* clients saves her feelings and the final sale.

POSING THE ARMS

To learn how to pose the arms, watch people as they are relaxing. They fold their arms, they lean back and relax on one elbow, they lie on their stomachs and relax on both elbows, or they will use their arms to support their chin and head.

To learn how to pose the arms, observe people as they relax. These are natural, comfortable positions.

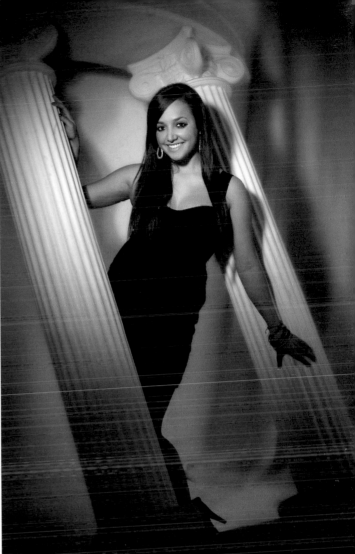

Posing the arms away from the body creates a slimmer view of the waist.

In general, the arms should be posed away from the body, not against it—and especially not pressing on it. When the arms touch the side of the waist, it appears that the body is wider. The arms appear to be attached to the torso, forming one larger mass.

Any time weight is put onto the arms it should be placed on the bone of the elbow. Putting weight on the forearm or biceps area causes the area to mushroom and appear much larger in size than it actually is.

TIP ▶ Your clients need to know how to dress to look their best and hide their flaws before the session day. If they don't wear the clothing that you have suggested, they must be billed for the time it takes to fix the problems that their decisions created. This information has to be given to them in writing (in a session brochure) or in the form of a video consultation. We use both, since we want even the most clueless clients to be aware of how they should dress and prepare for the session—and how much it could cost if they don't!

Posing the arms carefully also gives you the ability to hide problem areas, such as the neck, waistline, or hips. I look at the client once they are in the pose to see if there are any areas that, if I were them, I wouldn't want to see. If there is a double chin, I lower the chin onto the

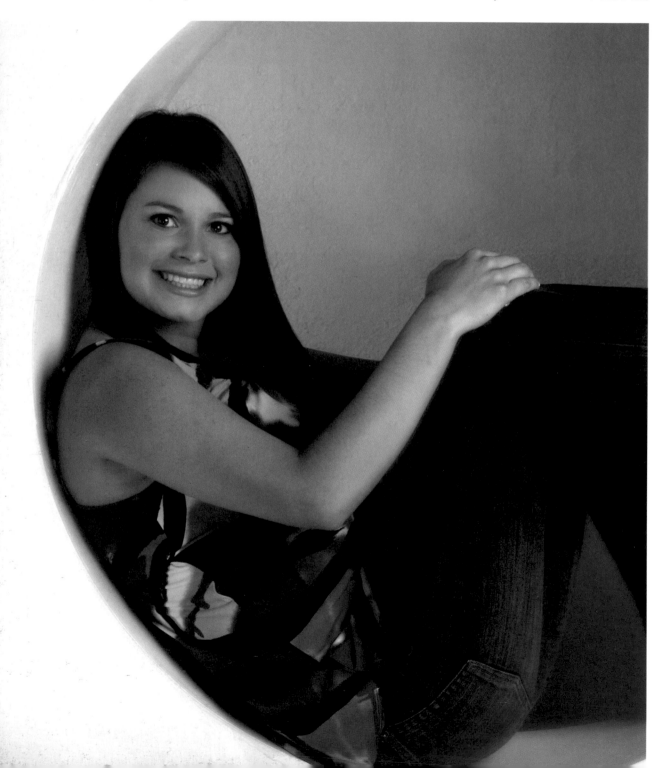

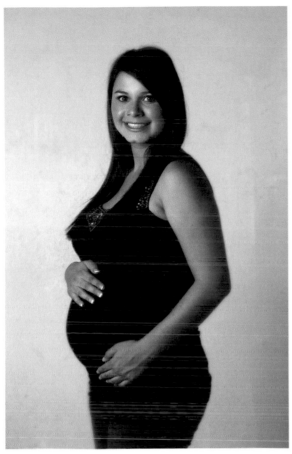

The arms can be used to conceal a subject's stomach area. Looking at the larger image (facing page), would you guess this woman was pregnant?

arms to hide it. If I see a not-so-flat stomach, I may extend the arms out to have the hands around the knees.

OBSERVE THE DETAILS

The key to posing is being observant. Don't be in a hurry to start snapping pictures. After taking a test shot, stop and study the image for at least ten seconds. By taking the time to identify and correct issues in posing, lighting, and expression, you'll see the number of obvious problems in your images go down considerably.

If you constantly find problems—issues you should have picked up on before the portrait was taken—coming out in the final proofs, hire someone with a good eye for detail to assist you in your sessions. Their eyes and focus on detail will save you the cost of their salary in lost or reduced orders.

The key to posing is being observant and diligently detail-oriented.

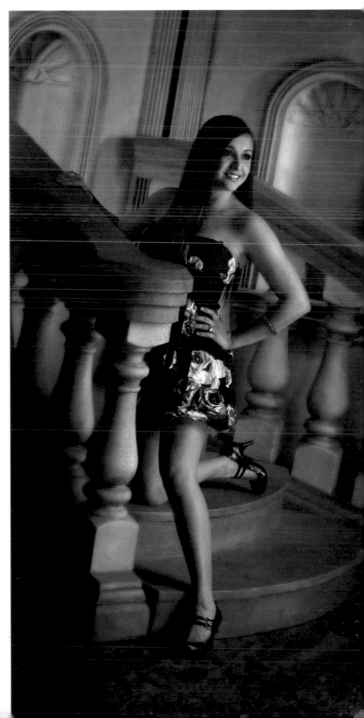

32 THE HANDS

Hands are one of the hardest areas of the body for photographers to pose naturally. Some photographers pose the hand like a 1960s mannequin, with every joint bent and the hand looking oddly elegant but demanding way too much attention. Others do nothing, letting the hands just dangle. Now *that's* artistry!

GIVE THEM SOMETHING TO DO

Hands are simple to pose: just give them something to do. When a hand is holding onto the other arm, resting on a leg, holding the arm of a chair, or supporting the face, it looks natural. It does not attract any attention to its pose.

Clients usually pose their hands very well on their own, if you explain where they are to place them. If you watch people relaxing, in fact, you'll see that they tend to fold their hands or rest them on their body—instinctively avoiding the unflattering "dangling" positions.

SHOW OR HIDE

If there is a reason not to show the hands, pose them out of view completely. If a hand is completely out of view, it won't bother the viewer; they can figure out there is a hand attached the wrist and arm. If one finger is obscured, however, it will not make sense visually.

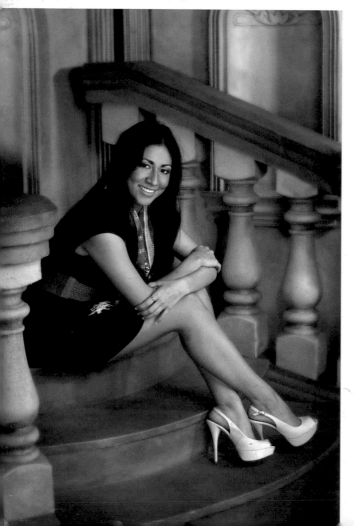

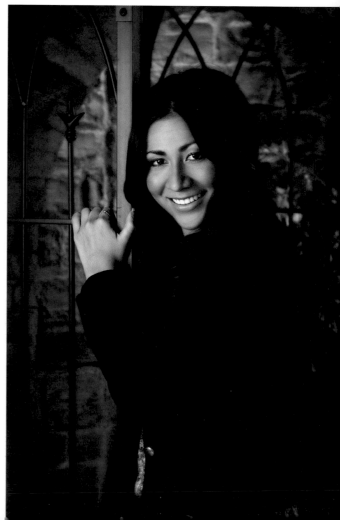

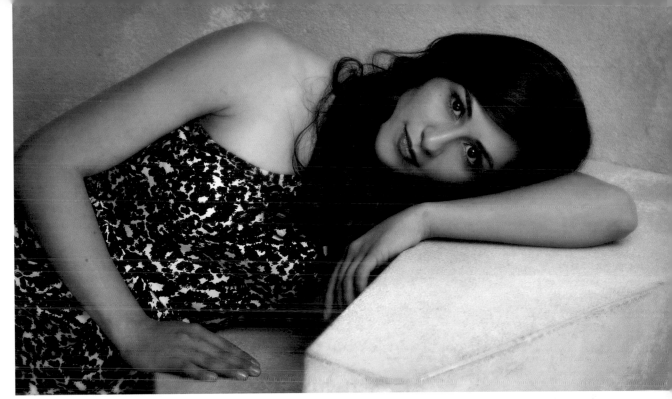

If you tell them where to rest their hands, most clients will naturally pose their hands in an appealing way (above and facing page). For guys, tucking the hands in the pockets is an effective approach.

FISTS

When posing the hands in fists, opt for a relaxed fist that doesn't make your subject look like he is about to join in on a brawl. Women should never have the hand in a complete fist. If a woman is to rest her head on a closed hand, try having her extend her index finger straight along the face.

HANDS IN POCKETS

Posing a guy with his hands in his pockets is another effective approach. Whether he puts his hands all the way in his pockets for a refined look, leaves his thumb out for a relaxed look, or hooks his thumbs in his waistline and makes a fist for a cowboy look, this pose gets the elbows away from the body and makes the hands look natural.

The best way to pose the hands is simply to give them something to do— something to hold or somewhere to rest.

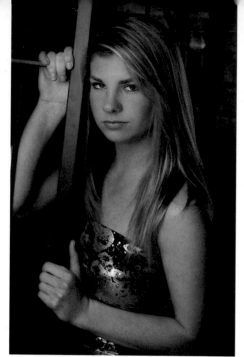

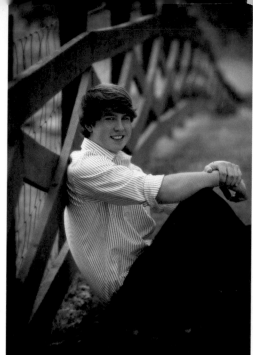

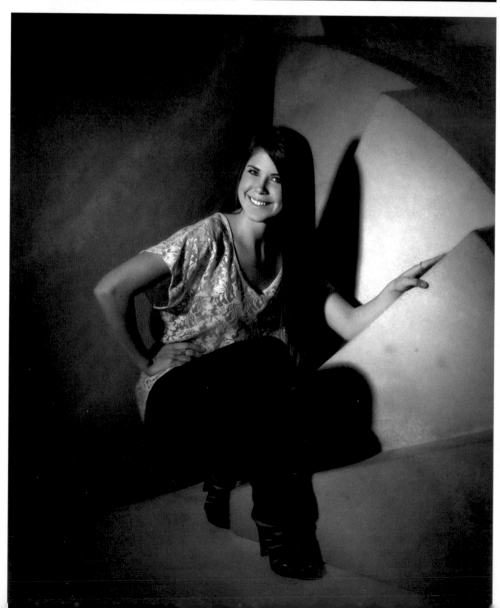

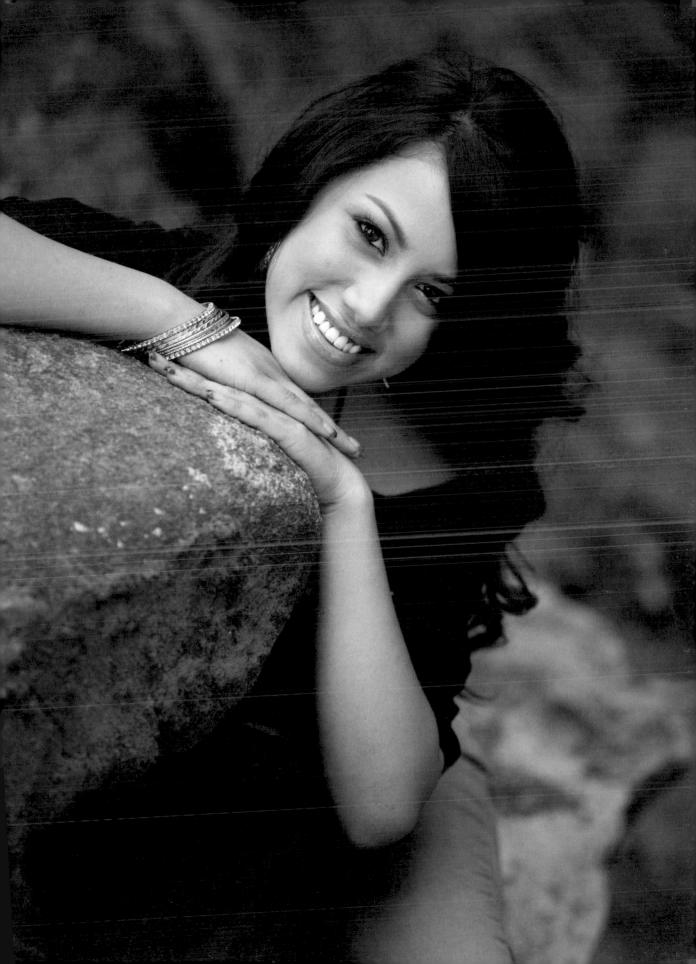

33 THE BUST/CHEST

Hiding or enhancing the bustline or waistline comes down to finessing the position of these body parts with respect to the main light. For women, the apparent size of the bustline is determined by the appearance of shadow in the cleavage area or the shadow cast beneath it.

To increase the shadow in the cleavage area, turn the subject away from the main light until you achieve the desired effect. To reduce the appearance of the bustline, reduce or eliminate the shadows in the same areas. This can be done by simply turning the body of the subject toward the main light.

The same lighting procedure can be used in the case of a man who wants to show off his chiseled abs. By turning the body just enough toward the shadow side of the frame, you will create shadows in each recessed area.

TIP ▶ Should a woman's breasts appear uneven, you need to address this problem. Dark, loose clothing can help. Another approach is to lower the camera angle and hide the smaller breast behind the larger breast that is closer to the camera. To further hide the inconsistent size, increase the shadow in this area. Shadow is truly our friend!

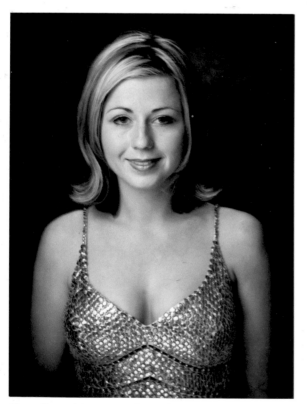 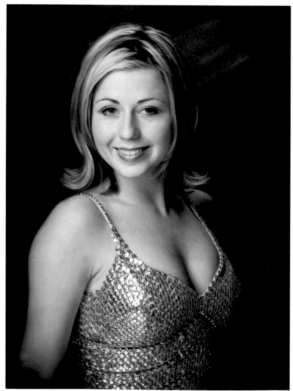

Turn the subject away from the main light to increase the shadows that enhance the shape of the bust.

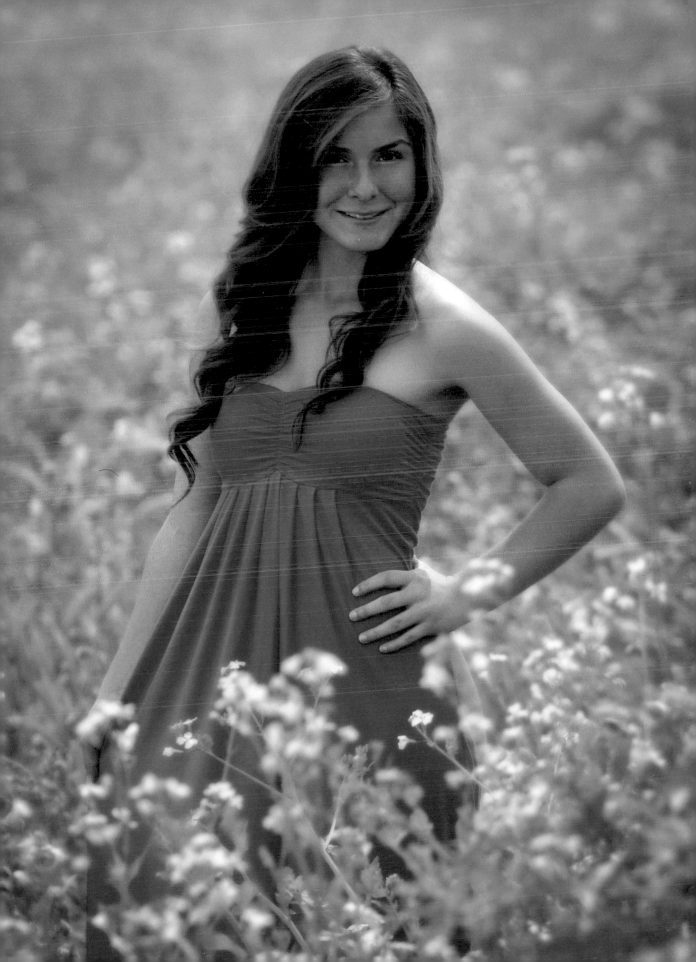

THE WAIST

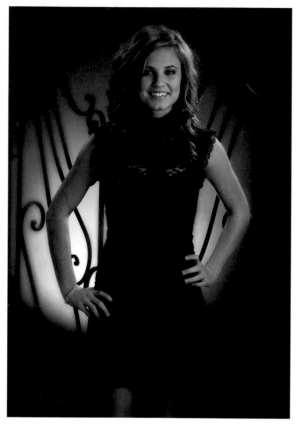 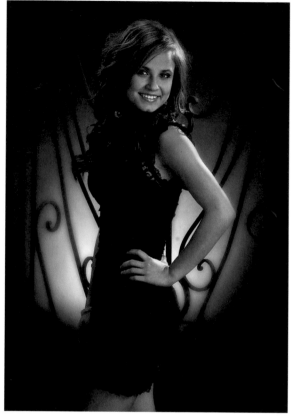

Women always want their waistlines to appear as thin as possible. Switching from a straight-on pose (left) to a pose with the body turned (right) helps to slim the waist.

ANGLE TO THE CAMERA

The widest view of the waistline is when the body is squared off to the camera. The narrowest view of the waistline is achieved when the body is turned to the side. So the more you turn the waist to the side, the thinner it appears—unless there is a round belly that is defined by doing so.

SEATED SUBJECTS

A common problem with the waistline occurs when the subject is seated. Even the most fit, athletic person you know will have a roll if you have them sit down in a tight pair of pants. There are three ways to fix this problem. First, have the subject straighten their back almost to the point of arching it. This will stretch the area and flatten it out. The second solution is to have the client put on a looser pair of pants. Third, you can use the arms, crossed legs, or even parts of the chair to hide this area.

Many photographers who lack an eye for detail also create the appearance of rolls simply by

failing to fix the folds in a client's clothing around their waistline. Believe it or not, as a professional photographer you are responsible for *every* detail in *every* session (assuming you actually want to sell the portraits you are taking). That includes wrinkles in clothing.

LYING POSES

Sometimes, especially when working with senior-portrait clients, a woman will want to show her entire body/outfit when her body size would make a closer composition a better choice. Lying poses help in cases like these. In this pose, you can hide the stomach area by having the subject lie down on it, then you can use the head and shoulders (along with a lower camera height and adjusted angle) to hide much of the body behind

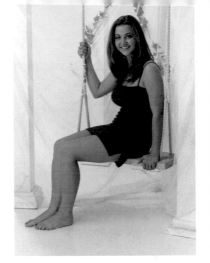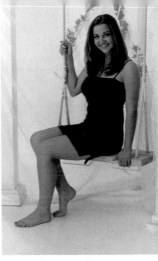

In a seated position, clothing and skin wrinkle (left), giving even the thinnest person a roll. If the person is thin, simply have her straighten her back, almost to the point of arching it (right).

them. This is one way to do a full length pose, even when the client's body type makes it an otherwise poor choice.

Lying poses like this have a lot of benefits. They maintain a nice face size (which moms like) while showing the whole outfit (which girls like). At the same time, they conceal or minimize the tummy, hips, and thighs—areas that many female subjects worry about.

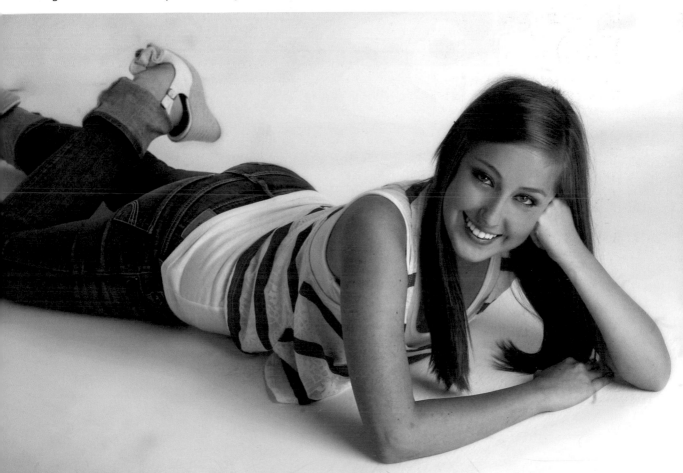

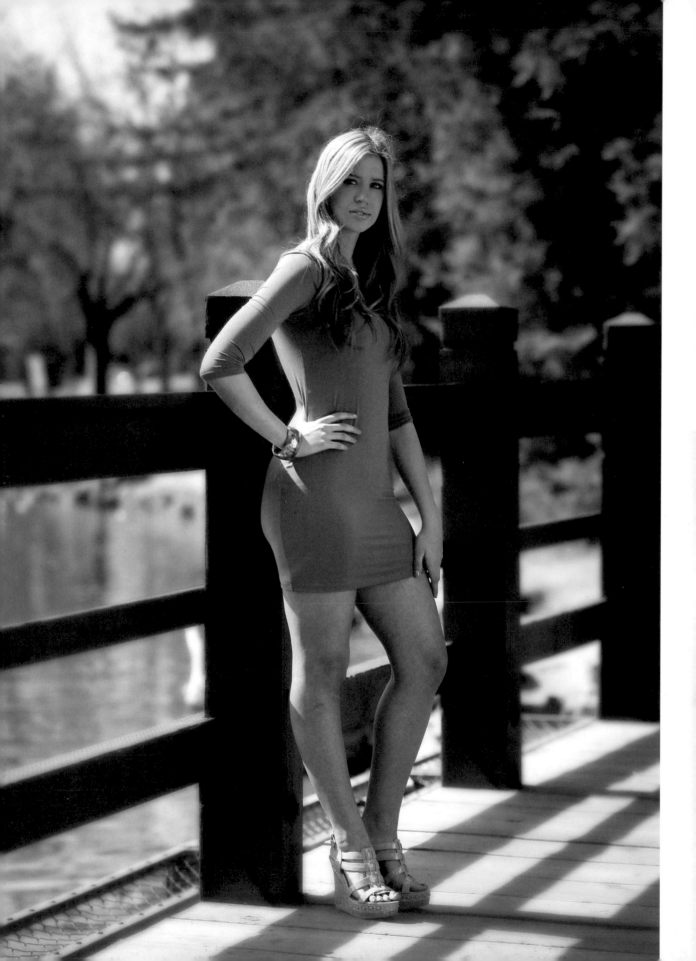

TURN THE HIPS

The first basic rule is never to square off the hips to the camera. This is obviously the widest view of the body. In a standing pose, rotate the hips to show a side view, turning them toward the shadow side of the frame if weight is at all an issue.

DIFFERENTIATE THE LEGS

Just as the arms shouldn't be posed next to the body, the legs should never be posed right next to each other in standing poses. There should always be a slight separation between the thighs. This can be done by having a client put one foot on a step, prop, or set. Alternately, you can simply have the client turn at an angle to the camera, put all their weight on the leg closest to the camera and the bend the other knee.

CHOOSE FITTED CLOTHING

Clothing also plays an important role in the appearance of the lower body. The baggy clothing that has been popular for the past few years, and dress slacks for both men and women that are much less than form-fitting, can sometimes make the thighs appear to be connected.

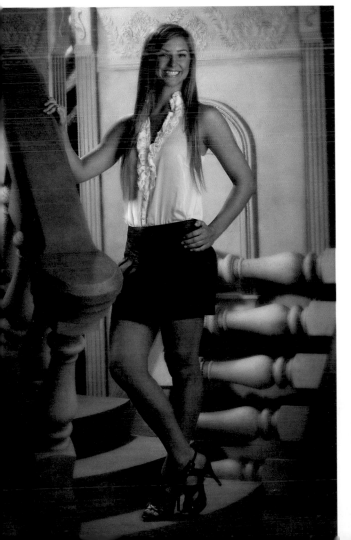

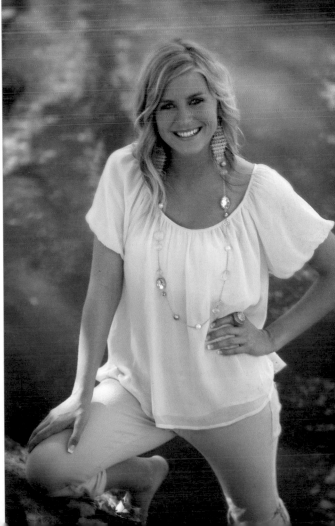

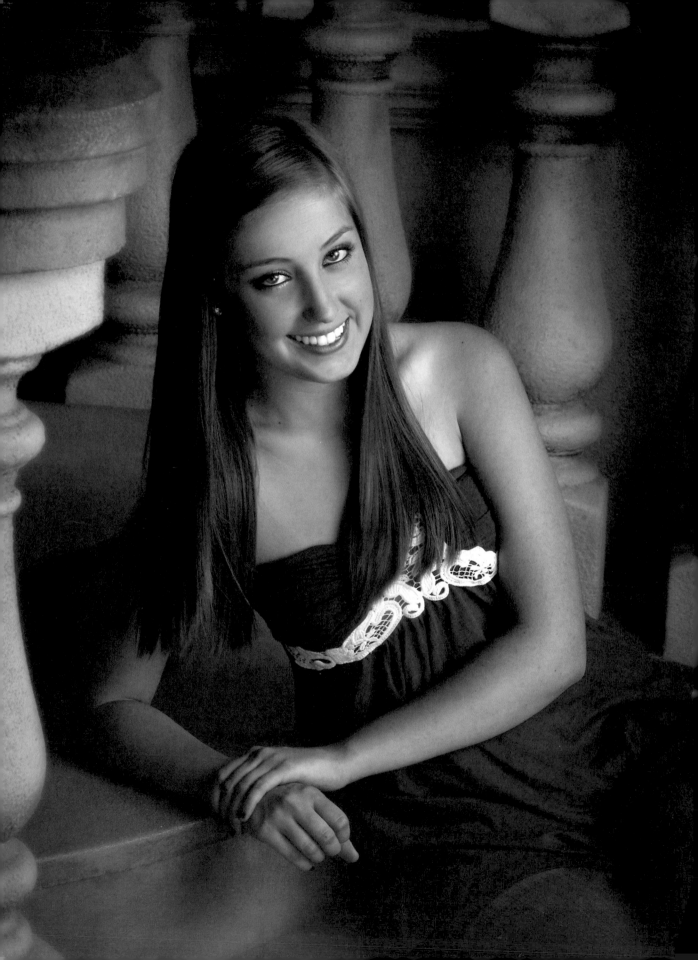

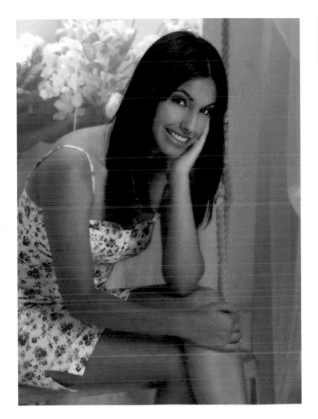

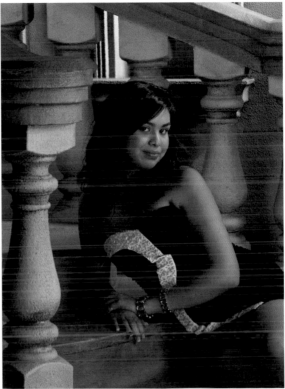

ROLL TOWARD THE NEAR HIP

If you sit a client down flat on their bottom, their rear end will mushroom out and make their hips and thighs look larger. If you have the client roll over onto the hip that is closer to the camera, however, their bottom will be behind them and most of one thigh and hip will be hidden.

DIFFERENTIATE THE LEGS

In seated poses, the legs must be differentiated, if possible. If the client has on a short dress, have her move her lower leg back and bring her upper calf over the top of the lower one. If pants are worn, the back foot can be over the front leg and the foot can be brought back toward the body, causing the knee to rise.

A PROBLEM AREA

When you separate the legs, make sure that the area between the legs (the crotch area) isn't unsightly. You may find this problem when the subject is wearing baggy jeans. It also occurs when you have a guy seated with his legs apart, then have him lean forward to rest his arms on his knees. The pose works well because this is the way guys sit—but the crotch area is pointed directly at the camera. You can use the camera angle and the arms to hide or soften the area.

In poses that have the subject on their side, whether lying completely down or supported by one or both of their arms, the thighs need to be posed in such a way that they are either defined (separated) or made to taper down to the knee. A very effective way to thin the hips and add impact to the area is to have the leg closer to the ground extend straight out, while the upper leg bends at the knee then comes down in front of the lower leg to touch the ground. This causes the hips to dramatically taper down to the knee and reduces the apparent width of the thighs.

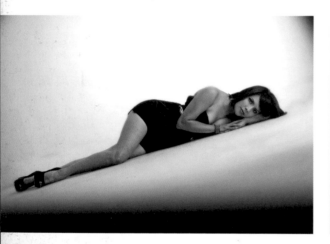

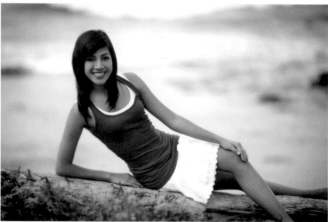

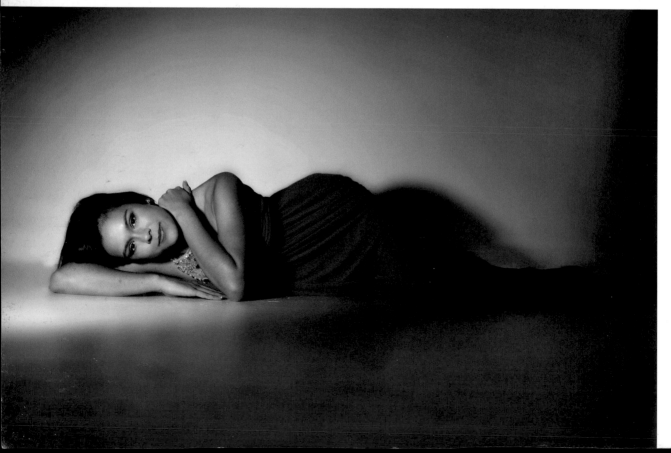

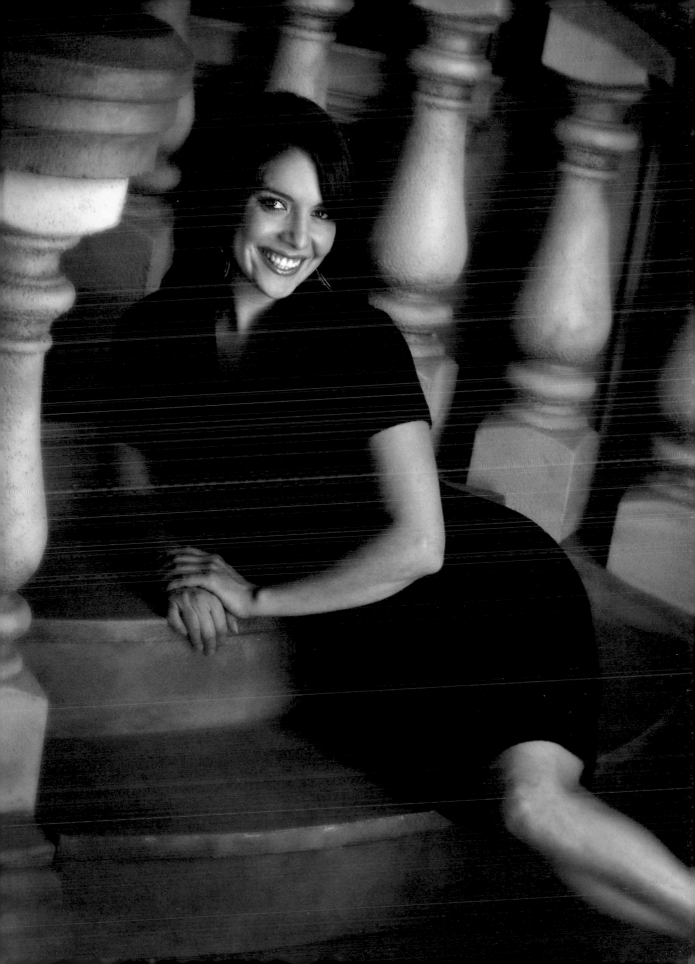

▼ FOR FURTHER STUDY

Young women seem to love this pose—and with good reason. It's one way to do a full-length pose without showing much of the dreaded hip/thigh area. By shifting the camera angle, you can control how much of the lower body is visible past the face.

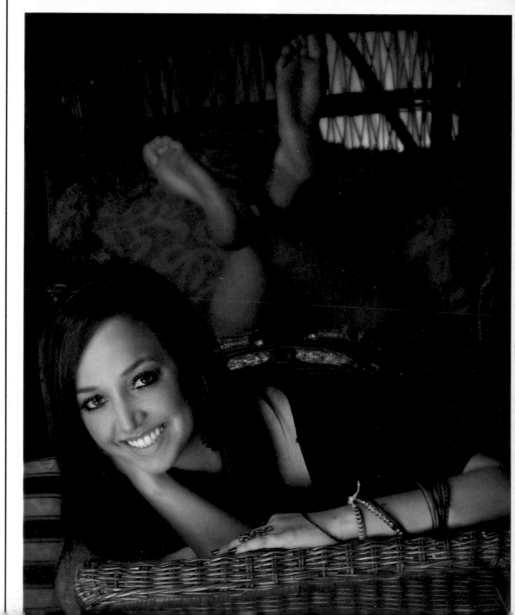

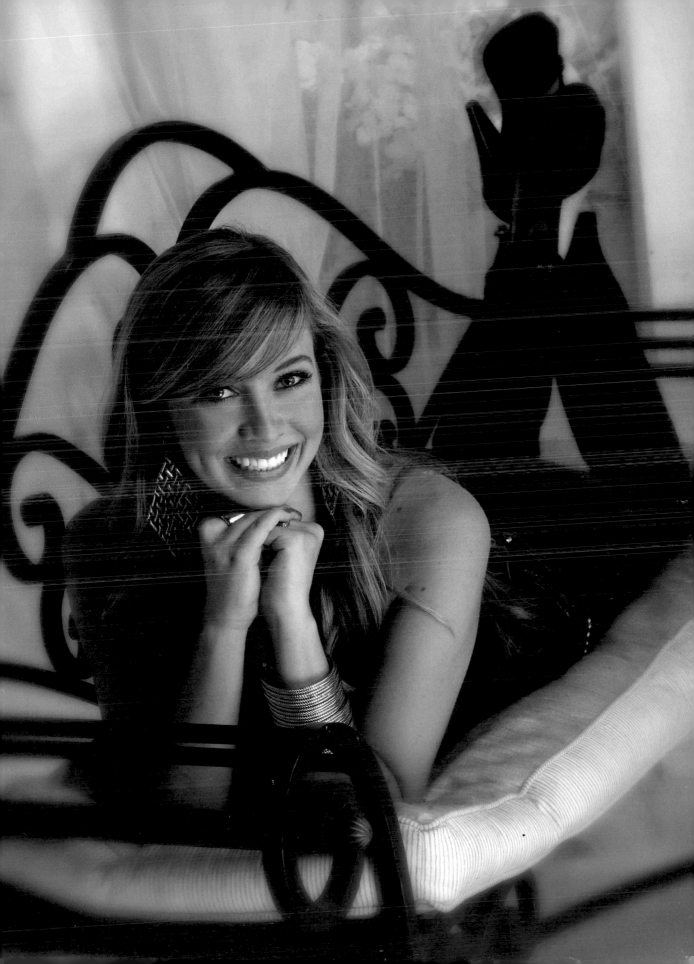

GROUNDED LEG, ACCENT LEG

Pick a grounded leg and what I call an "accent" leg. The grounded leg will support the subject's weight. The accent leg, usually determined by the pose and the direction of the body, can cross over, extend out, bend or raise up, but it can never duplicate what the grounded leg is doing.

If you use this strategy, you will have cut your work in half since you'll only need to pose one leg instead of two.

Take the classic "James Bond" pose. In this stance, the weight is put on one leg and the accent leg is crossed over with the toe of the shoe pointing down.

In these poses, the leg closer to the camera supports the subject's weight. The other leg is the accent leg.

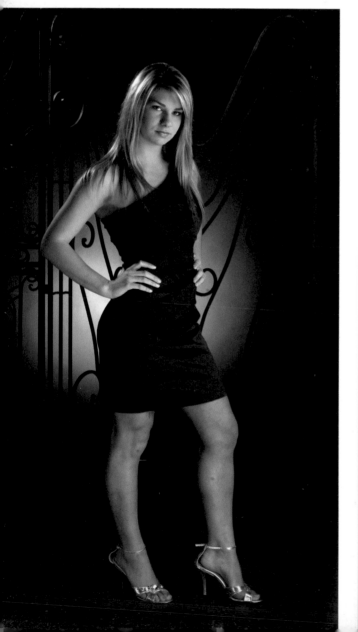

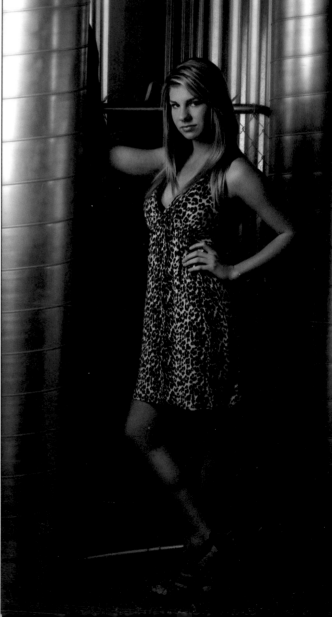

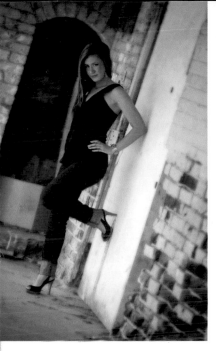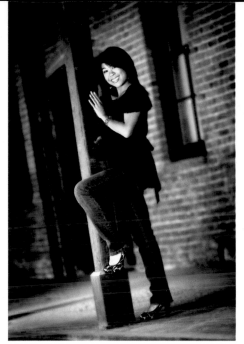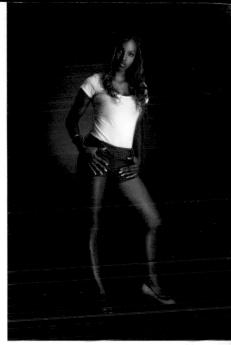

When the subject has their weight on one leg, you cut your work in half— there's only one leg left to pose!

GROUND THE POSE

Even in a seated pose, one leg normally extends to the floor in order to, for lack of a better word, "ground" the pose. The body needs to be grounded. Have you have seen a person with short legs sit in a chair where their feet don't touch the ground? While this is cute for little kids, a pose that is not grounded looks odd for an adult. If you have someone whose feet don't touch the ground, have them sit on the edge of the chair so at least one foot touches the ground, or have both feet brought up into the chair. This grounds the pose by using the chair as the base.

In a seated pose where one leg is grounded, the other leg becomes the accent leg. The accent leg can be "accented" by crossing it over the other, bending it to raise the knee, or folding it over the back of the head (just kidding)—but you need to do something with it to give the pose some style and finish off the composition.

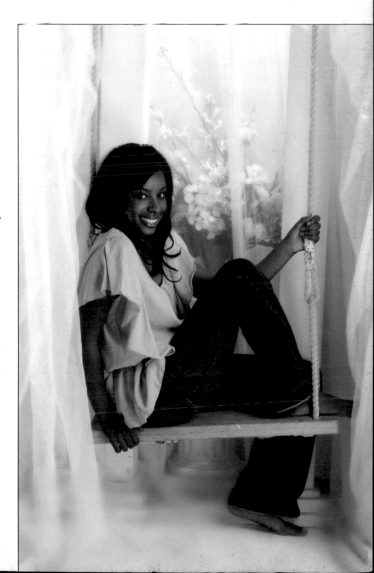

With two legs, you can shift your weight to one leg or the other. This changes the appearance of the hips, bottom, and thighs. With the body in a side view, if the weight is shifted to the hip closer to the camera, the bottom looks fuller and it flexes the muscle in the thigh. In some women, this is a good thing; in others, it draws unwanted attention to problem areas.

In standing poses, the subject's weight distribution or weight shifting is very important. One mistake photographers often make is shifting the subject's weight to accent the hip closer to the camera. This works with a very thin or very curvy woman, but it enlarges the bottom and thigh, which isn't salable for 90 percent of women.

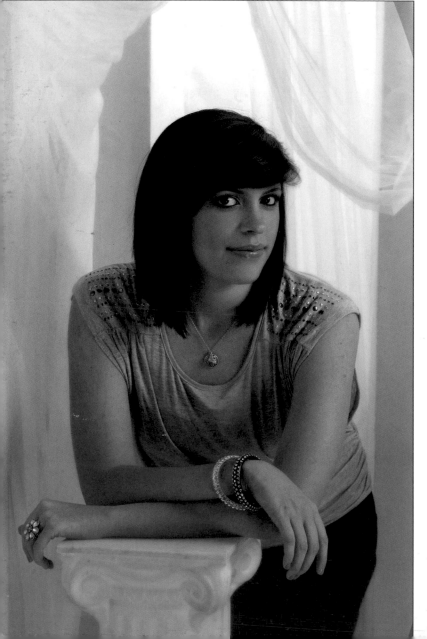

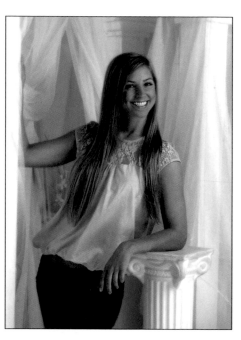

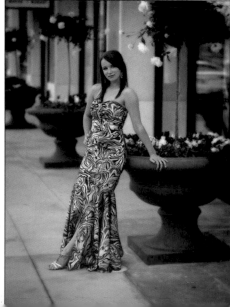

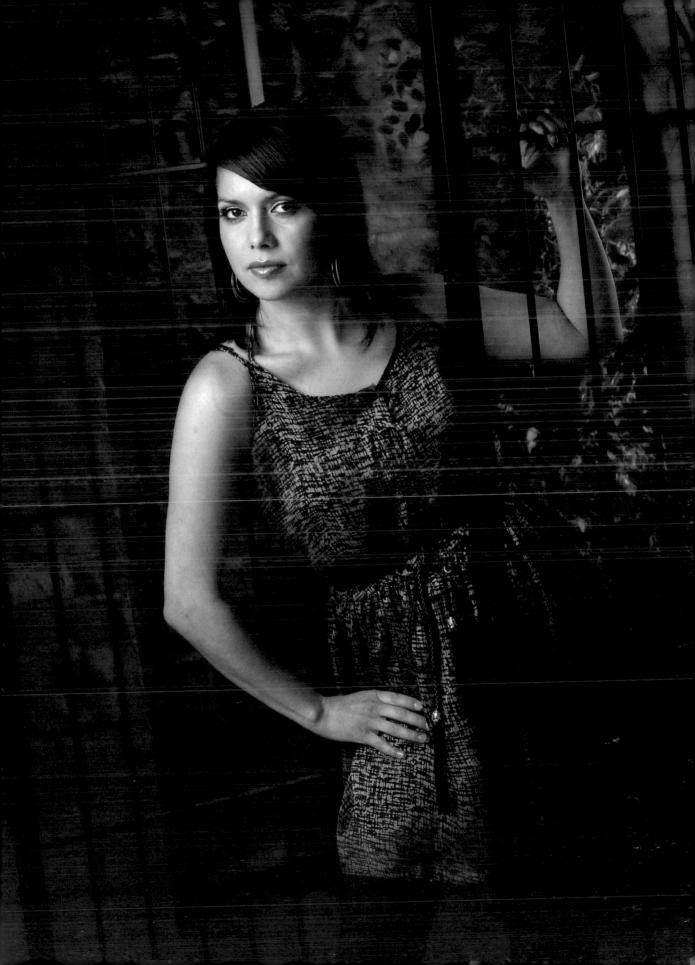

WHAT TO AVOID IN LEG POSING

There are literally hundreds of ways to make the legs look good. In fact, it's easier to isolate what *not* to do.

BOTH FEET FLAT ON THE GROUND
In a standing pose, never put both feet flat on the ground in a symmetrical perspective to the body. This is static, stiff, and boring.

THE LEGS SIDE BY SIDE
Never position the feet so close together that there is no separation between the legs/thighs.

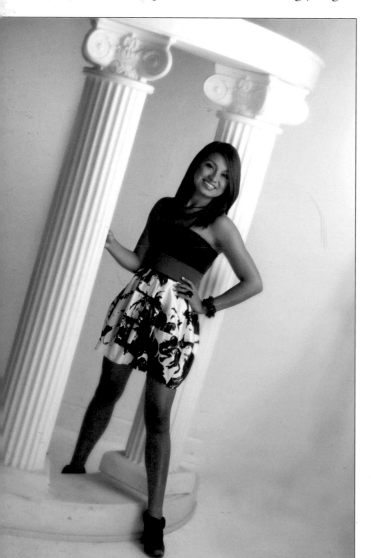

This makes the legs look thicker because they are not defined as two legs. Visually, they appear to be one connected surface area and look thicker.

BOTH LEGS IDENTICAL
Never do the same thing with each leg (with a few exceptions, like when both knees are raised side by side). One leg is to support the weight of the body, while the other leg is the accent leg to bring interest to the photograph and made the legs look appealing.

BOTH FEET DANGLING
Never have both feet dangling; one must be grounded. Otherwise, the subject will look awkward and unsettled.

THE ACCENT LEG TOO HIGH
Never bring the accent leg so high that it touches the abdomen. This causes mushrooming and distortion that makes the leg, hips, and torso look heavier than they are.

EXPECTING ANYTHING TO "ALWAYS" WORK
There is no one pose that will always work. Because of how flexible clients are (or are not), as well as how their bodies are designed, no single pose—no matter how simple it is—will make everyone look good. This is the golden rule of posing: when a client appears to be having a problem with a pose, scrap it. Don't struggle for five minutes trying to get it to work.

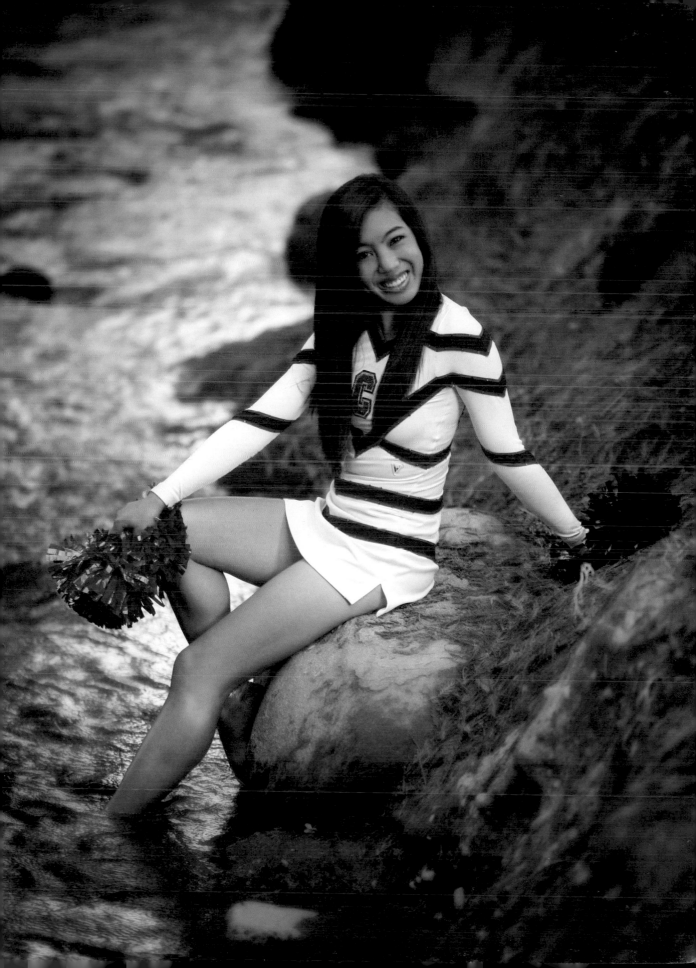

Legs are one of those areas of the body that either look great or don't. Luckily, if a woman has beautiful legs, she will want to show them; if she doesn't, you will typically see it in her clothing selection. However, there are also those women who live in denial. When this is the case, it's time for some tough but tactful love.

ANKLES

The ankles are not a problem for most guys, but they can be an issue for many women. The "cankle" (the look of the calf connecting directly to the foot) can best be handled by suggesting pants, camouflage the area with a foreground element, or taking the photos from the waist up.

MUSCLE TONE

Legs appear toned when the muscles that run along the outside of the thigh and calf are flexed and visible. These muscles usually become more readily apparent when the heels are raised, as they are when wearing high heels. (If the client's legs are very heavy, however, the muscles won't be visible even when flexed and the legs won't look toned.)

HOSIERY AND TANNING

If any part of the legs show, they should appear to have color; porcelain skin doesn't work on legs. If the subject's legs are pale, suggest she bring nylons or use a self-tanning product.

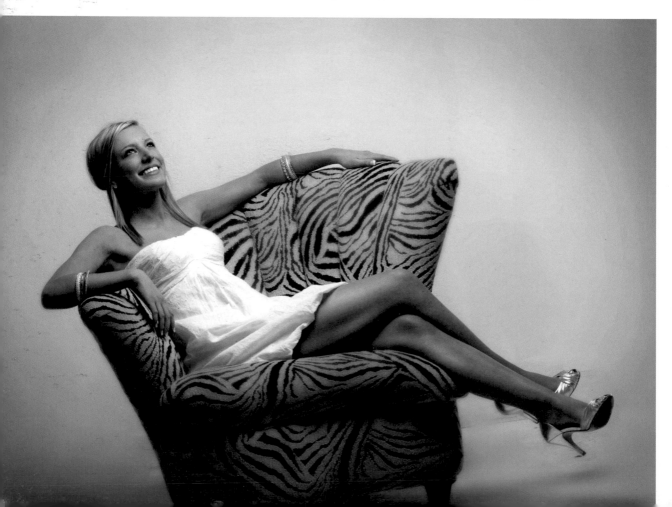

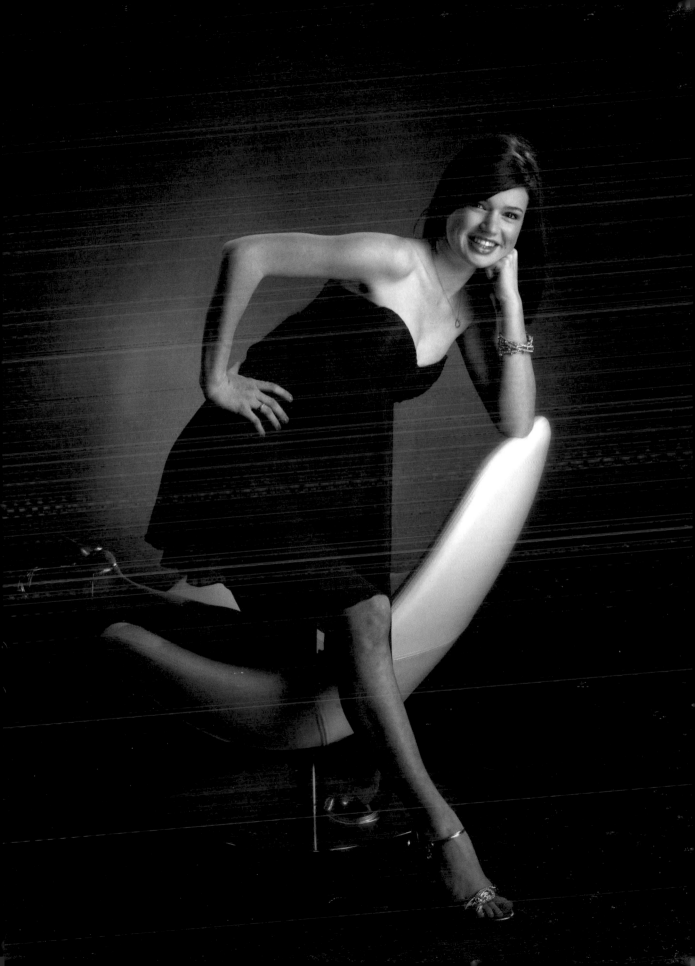

Cut your leg-posing
work in half. Choose
one leg as the weight-
bearing leg, then con-
centrate on posing
the "accent" leg.

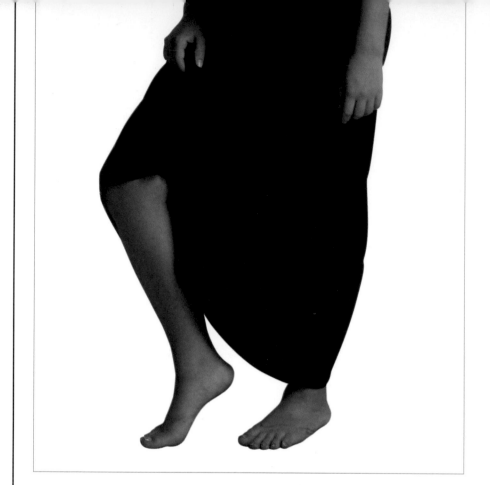

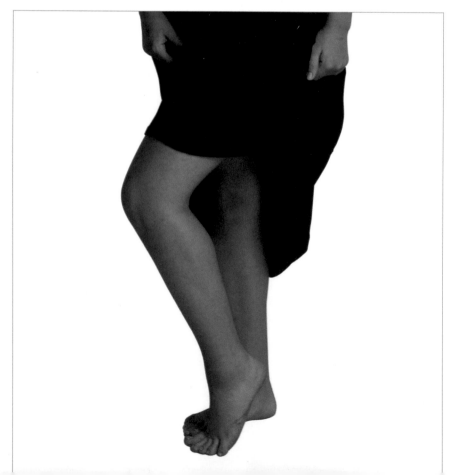

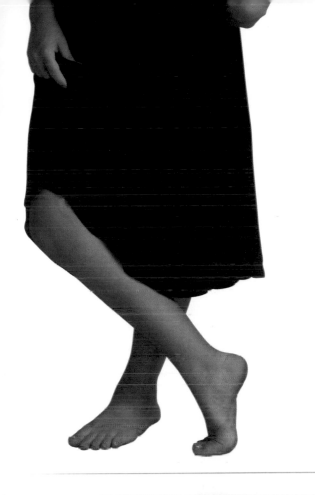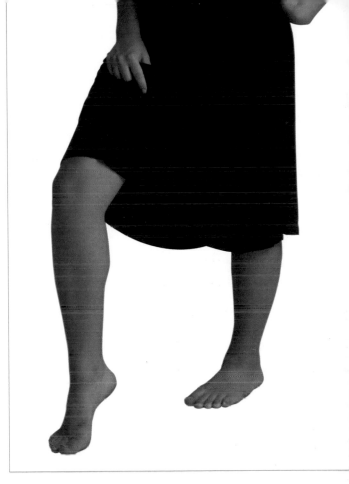

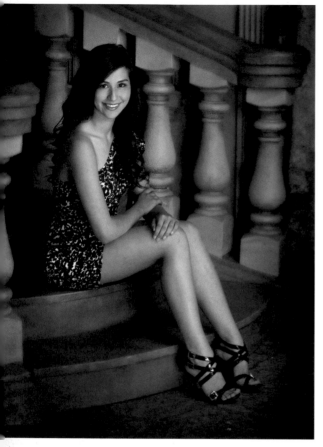

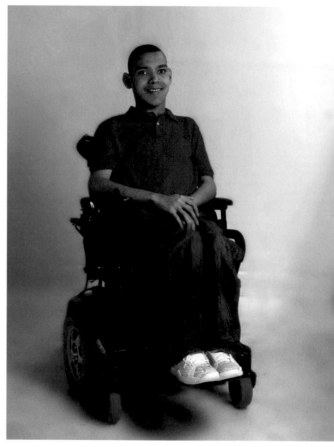

BARE FEET

Clients don't want their feet to appear large or their toes to look long. Also to be avoided are funky colors of toenail polish, long toe nails (especially on the guys), or (generally) poses where the bottom of the feet show. If the bottom of the feet are to show, make sure they are clean.

MINIMIZING THE APPARENT SIZE

Bare feet can be made to look smaller by pushing up the heels of the foot. This not only makes the feet look better, but also flexes the muscles in the calves of the legs, making them look more shapely.

SHOE SELECTION

The subject's footwear should reflect the feeling of his or her outfit. If the client chooses an elegant dress, high heels will add an elegant look, help her legs look toned, and make her feet appear smaller. If the client is in a business suit, shoes should be worn that reflect the same professional look. As the clothing gets more casual, tennis shoes or bare feet are the best choices.

43 POSE FOR A FULL-LENGTH

Create every pose as if you were taking the portrait full length. Even when the legs are not showing, as when photographing a woman in a full-length dress or wedding gown, the legs should still be posed for an elegant look. While the legs might be covered with material, the contours of the legs are still visible through the fabric of many dresses. It also provides practice for times when the subject's legs are showing.

This approach also makes the client feel complete. A certain look comes over a subject when they are posed completely and know they look good. If you don't think this is true, imagine how you would feel with your arms and shoulders posed properly but your legs in some terribly awkward stance. It's like being dressed for success and looking good—right up until someone tells you your fly is open.

Additionally, posing the entire body speeds up the session by allowing you to go from head-and-shoulders, to three-quarters, to full-length with a zoom of the lens (and perhaps slight posing tweaks). It also gives you additional practice at designing full-length poses. Just take my word for it: pose the entire body—it's good for both you and the client.

44 EMPHASIZE THE POSITIVE

How much or little notice the viewer will give any particular part of the body is a major factor in your posing choices. How do you decide what parts should be emphasized? You do it by determining what the client loves about herself. That's what she'll want to see in her photos. You can often do this just by observing your subject.

Let's say a woman comes in with all the typical signs of a recent breast enlargement (obvious cleavage showing, no bra—and yet her breasts defy the laws of gravity, despite the fact that she is forty years old). This woman has just undergone major surgery to make her breasts a noticeable feature and she will want you to show off her cleavage in all its glory. (*Note:* It doesn't matter what your personal feeling may be about this kind of enhancement. When you are paying someone to take *your* portraits, then your opinion will matter; right now it doesn't.)

The same holds true for a woman with long legs. If she brings in nothing but short skirts, shorts and high heels, you can be sure she wants to see her legs emphasized in her images. If your subject is clearly a very athletic woman who works out constantly to have a tiny waistline, design a portrait that makes the most of her slim physique.

Whether it's long legs, a great smile, vibrant eyes, or a shiny head of long hair, emphasizing these "areas of beauty" that your client is proud of will result in more salable portraits.

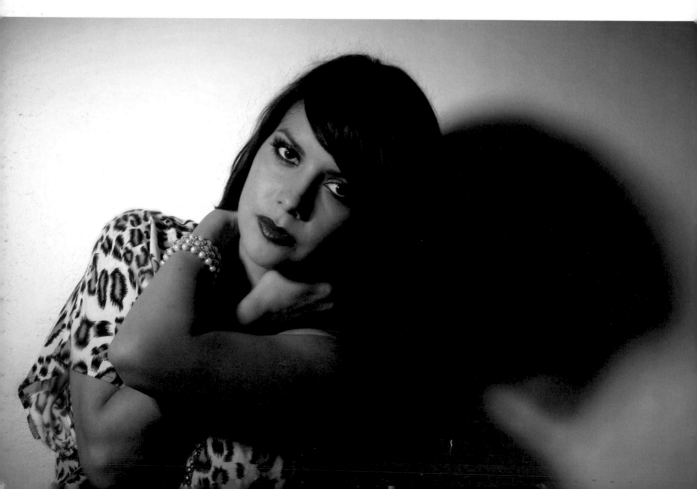

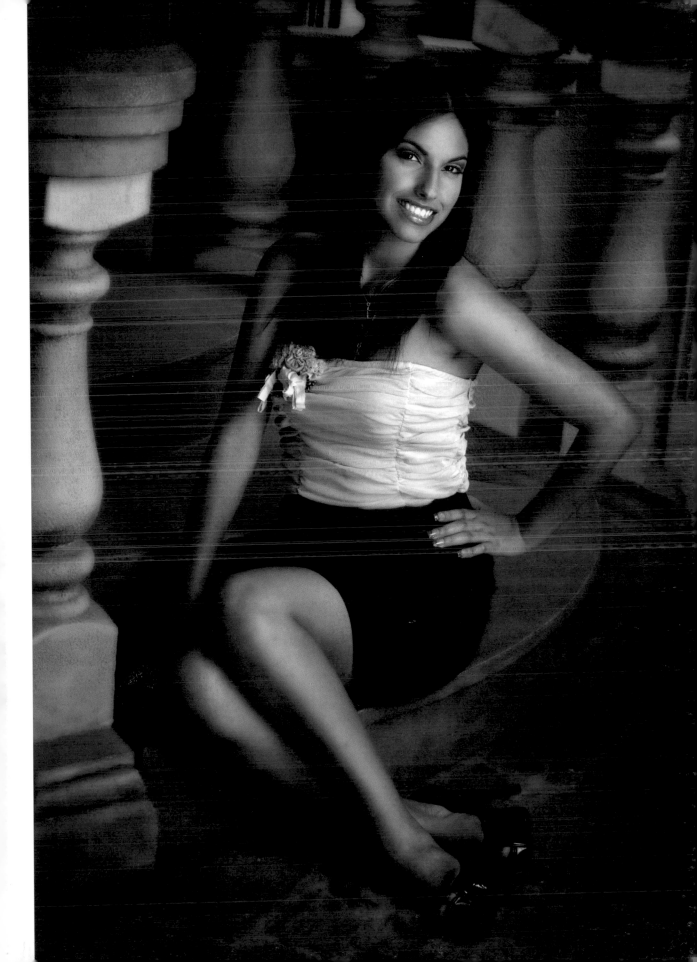

45 MINIMIZE THE NEGATIVE

The flip side of this is that you must hide or minimize any areas that could embarrass the client if they showed. For guys, this could include (among other things) a large waistline, double chin, or baldness. For women, potentially embarrassing features include things like a large waistline, wide hips and thighs, or "cankles" (where the calf of the leg goes straight down to the foot with little reduction in size at the ankle).

I use lighting, posing, and even parts of the scene to hide or disguise these less-than-flattering parts of the body. In many of the seated, full-length poses you see, the knee will be brought up to hide the tummy area. In other full-length poses, you will see that the arms follow the same line as the waistline. You will see many women lying on their stomachs—which is not only cute, but also hides the tummy and minimizes the view of the hips and thighs.

If you review the previous sections in this book, you'll see that many of the techniques we've already covered can be used to address areas of concern for your subjects—but only if you take the time to 1) identify those areas of concern for each individual and 2) implement the proper technique for disguising these areas during the session.

> **TIP** ► I love hearing photographers at seminars say things like, "You don't sell many of these, but they sure are fun to take!" As long as the girl is pretty and showing a lot of cleavage or the guy is showing his six-pack, everyone is happy. In the real world, though, our clients aren't always perfect, and it takes interpersonal skills and technical know-how to get great-looking images of every subject.

Virtually everyone has things about their appearance they'd prefer not to see in their portraits. For women, the upper arms, waist, and hips are almost universal areas of concern. As you can see by comparing the two photos seen here, simple choices in lighting, posing, and set design can conceal or minimize the areas that might concern a client, resulting in a flattering, salable portrait.

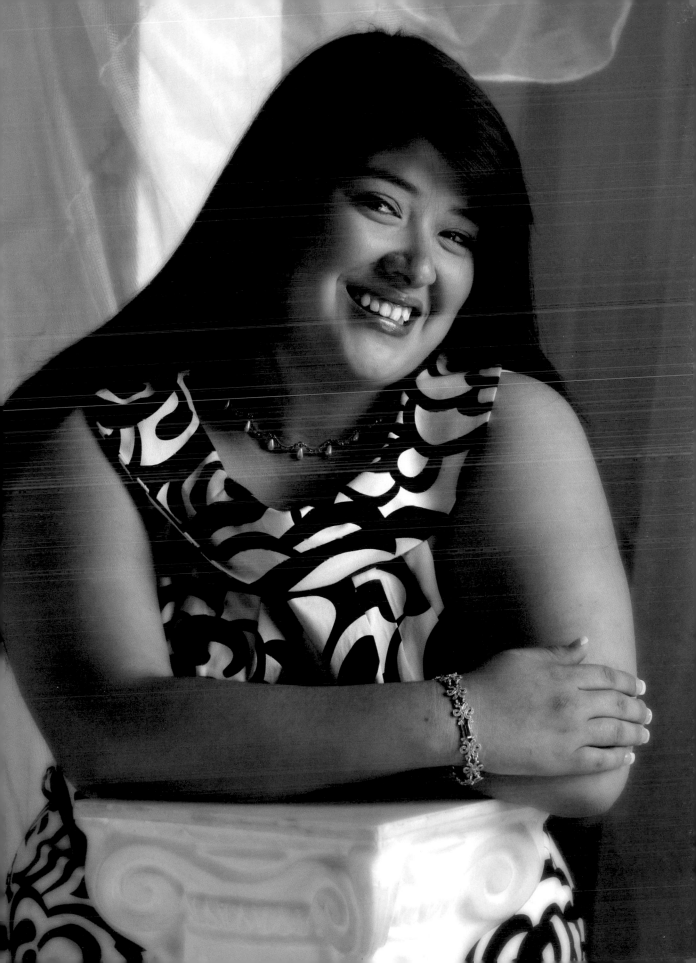

Posing in the outdoors is different from posing inside the studio. When we are working inside the studio, we can choose from different props and posing aids—all the elements of a background or set. We can then position the client at the desired height (whether it's standing, seated in a chair, lying on the floor, or reclining on a couch) and begin to work with the pose we have in mind.

Choose a Setting

Outdoors, the only thing you know you will have for certain is the ground for seated poses and standing poses. Therefore, you must look for areas that offer you a variety of other op-

tions for posing the client at the desired height. This might be rocks, the bank of a river or creek, stairs, or even a low tree branch.

When I look for outdoor locations, I look for natural-looking areas, not manicured gardens or parks. Natural locations—like a river or creek, a forest, or an area of a city park that is allowed to grow naturally—generally offer the best options for posing and the most scenes within a small area. Banks, fallen branches, and stumps all give me areas to pose my client.

Select an Appropriate Pose

Once you select an area that provides you with many heights and posing options the next step

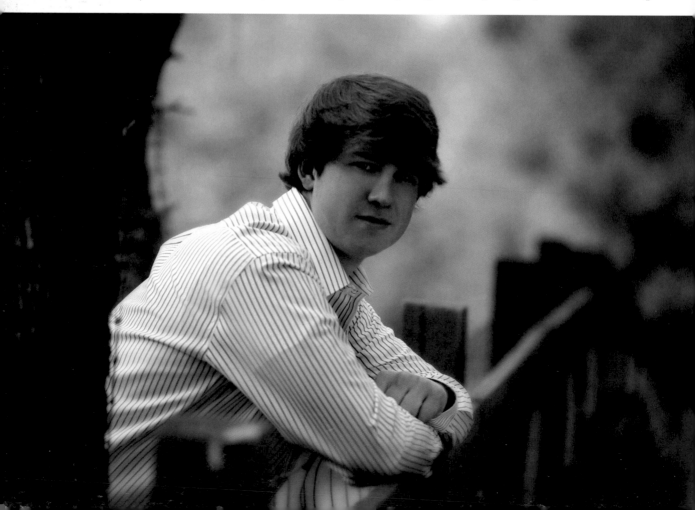

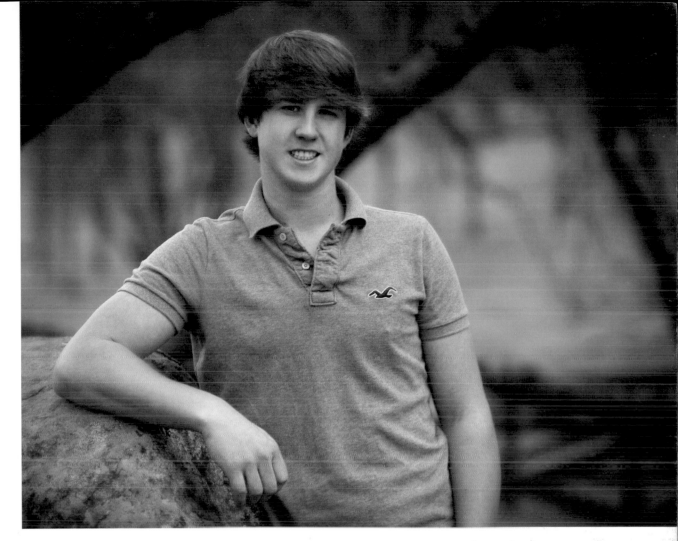

is to select poses that fit the overall look of the images you are trying to create for your client's tastes.

Too many photographers fail to connect the many elements of a photograph together to produce an images that visually makes sense. Keep in mind that each pose produces a certain look—and that look needs to coordinate with everything else within the frame. You have to go beyond just remembering simple poses and begin to consider the feeling they produce and what variations are possible to achieve different looks.

For example, when posing a young lady on the ground, you could have her lie on her stomach, sit on her hip, or sit flat on her bottom with her knees up and resting on the them. While these three poses are all casual in nature and well-suited to an outdoor scene, each pose shows a little different side of the same person.

TIP ► You have to study the poses you currently use and understand what they visually translate to in the portrait. Once you understand that, you can look for simple changes that will allow those existing posing to coordinate with other styles of clothing and locations.

▼
FOR
FURTHER
STUDY

A simple outdoor location, here a field of yellow flowers, can provide almost limitless posing opportunities. If you like, consider adding a posing aid (like a fancy chair) to open up even more options.

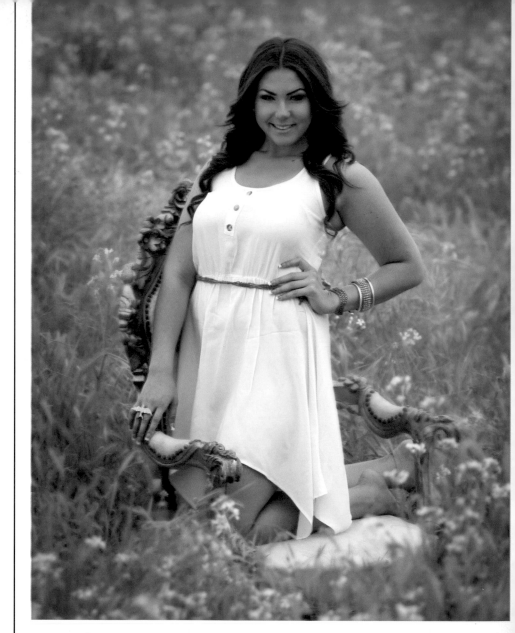

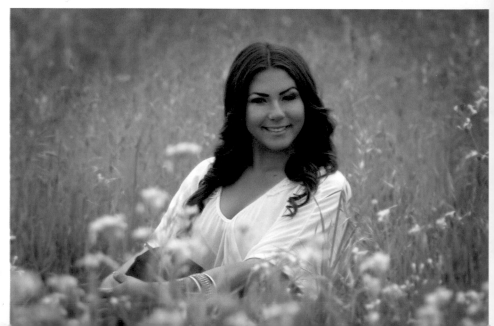

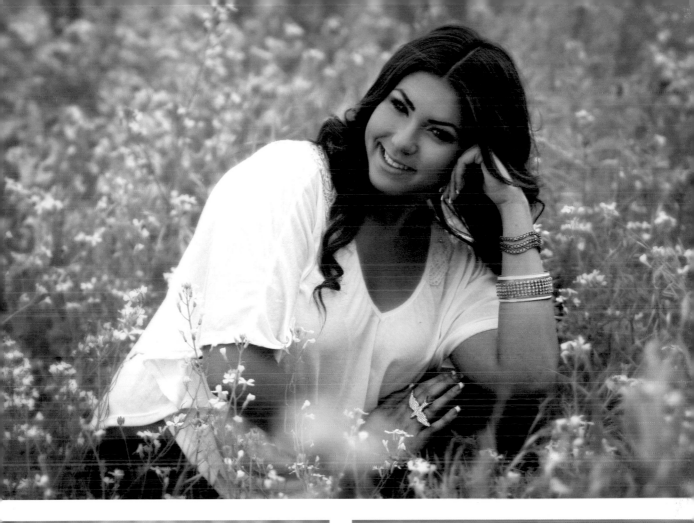

In some ways, posing women is much more difficult than posing men; in other ways, it is much easier.

Women constitute the majority of the clients for the average studio. They have more portraits taken of themselves and are typically the ones who organize portraits to be taken for weddings, families, seniors, and children. Women also tend to be more comfortable in front of a camera. Additionally, our options for posing women are much more varied than those for posing men.

The huge challenge of posing women, however, is the high standard of beauty that society tells all women they must meet.

THE STANDARD OF BEAUTY

Women, much more than men, tend to be very critical of portraits of themselves. Because women are held to a higher standard of beauty than men, most women feel as though they must look perfect in a portrait. Unfortunately, today's standard of beauty for women is completely the opposite of almost all real women. Women are shown size-3 starlets in movies and size-0 fashion models—not to mention "reality" shows that are anything but reality. Believe or not, most housewives in Orange County don't act or look like the ones on the show. They don't all bleach their hair "Playboy blonde," have large breasts that look like balloons ready to pop, or have a plastic surgeon standing by to suck out any fat pocket that should appear if the housewife actually decides to eat something.

This warped perception of reality, in regards the standard of beauty for women, is killing women's sense of beauty and confidence in their own appearance. You can't feel good about your size-10 body when television defines anything above a size 6 as a "plus" size.

Now, many male photographers reading this are wondering what on earth all this has to do with photographing a woman. Let me tell you: it has *everything* to do with photographing a

Does your subject want to look like the girl next door (left) or is she looking for something a little more alluring (facing page)? You have to understand what each woman is looking for *before* creating her images.

woman. Until you understand where a woman is coming from, you have little chance of making her happy when it comes to posing.

DIVERSE STYLES

Another challenge that women have is the number of different styles of portrait products that are designed for them—and for the many different roles they play. Does a woman want to look like someone's daughter? Someone's mother? Someone's wife? Someone's lover? Or the sexy-looking girl on the cover of a biker magazine? These are choices that most men simply don't have—and don't care about.

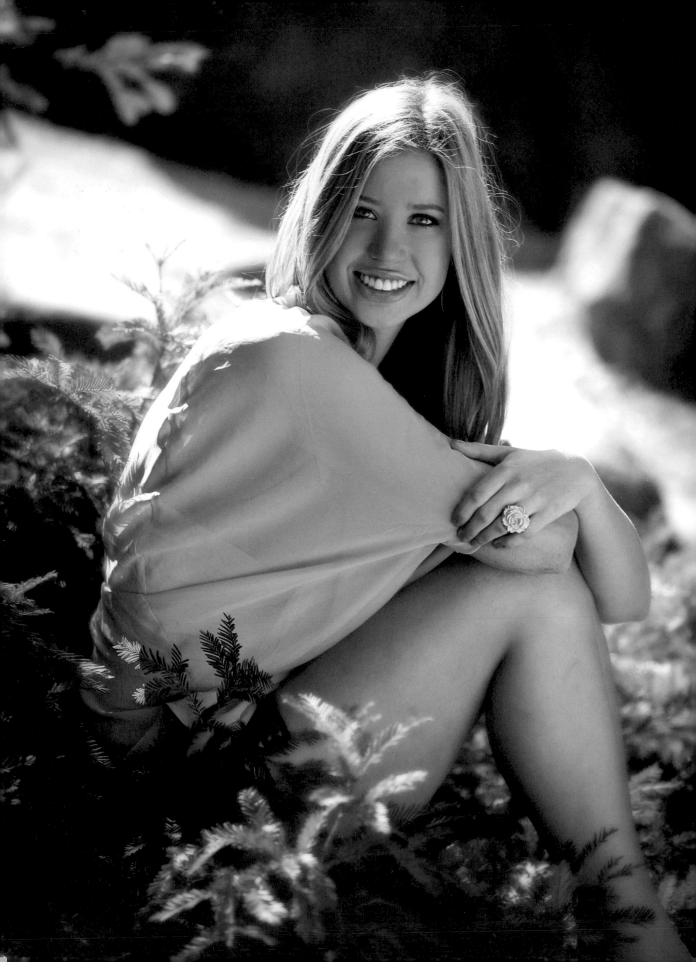

The factors noted in the previous section lead to one obvious conclusion: the first part of photographing of women has to be communicating with them. You have to find out what the woman who will be in front of your camera actually wants in her session. Then, you have to determine what concerns she might have about her own appearance.

EVALUATING HER NEEDS

You can't count on preconceptions to determine what kind of images your client wants to create. You must talk with the woman about what she wants—how she plans to use her images.

For example, you might see an attractive young lady come into your studio with a selection of clothes that are sexy. Those clothes, combined with the look of the woman, might lead you to believe she is coming to get alluring portraits for her boyfriend. However—surprise!—she just received her real estate license and needs professional portraits taken. Her clothing happens to be what she owns and doesn't represent her new profession. It is up to you to find this out and make the clothing she has brought in work for the type of portraits she needs produced. If you don't, the portraits you create will be useless to her—and she probably won't buy them.

EVALUATING HER CONCERNS

You also need to understand what parts of the woman's body she wants to emphasize and what parts she would rather hide. Of the parts of the body that show, you need to know how she feels about them. Some women are very proud of large breasts and want to show them; other woman are embarrassed by their large breasts and want to minimize them.

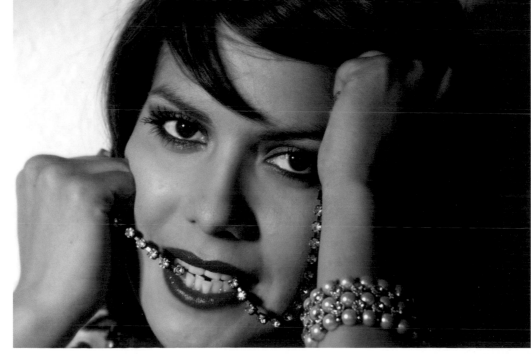

A good portrait session is always based on good communication with the subject. Almost every problem you'll encounter with clients can be traced back to a lack of communication.

THE CLOTHING SETS THE TONE

The clothing selected for the portrait will, to a large degree, dictate many other features of the portrait. The background, lighting, pose, and any props selected must all make sense visually if the portrait is to have a cohesive, professional look. This makes choosing the clothing an incredibly important decision—not one that should be taken lightly.

MAKE FLATTERING CHOICES

Above all, the chosen clothing should flatter the client. The easiest way to minimize problem areas is to cover them with clothing; doing so will make your posing job much easier.

One problem that photographers often have, for instance, is that many women who don't have perfectly long, lean legs choose to wear dresses rather than pants. This exposes any problems. If a person's legs are not attractive, but the image has to be full length, dark pants/jeans are a better choice.

Likewise, if a woman is concerned about the size of her upper arms, covering them with long sleeves (particularly in a darker color) is the easiest way to minimize the problem in her portraits.

PAY ATTENTION TO DETAIL

Portrait photography requires attention to detail. Poor fit, hanging threads, undone buttons, an untucked shirt that gives the illusion of a large tummy, or a slight bit of a woman's nipple peeking out of a low-cut dress—these are not problems you should find when you enlarge the image in viewing. You should be looking for and fixing any little problems like these when you are posing. A few seconds of being observant will save hours in Photoshop!

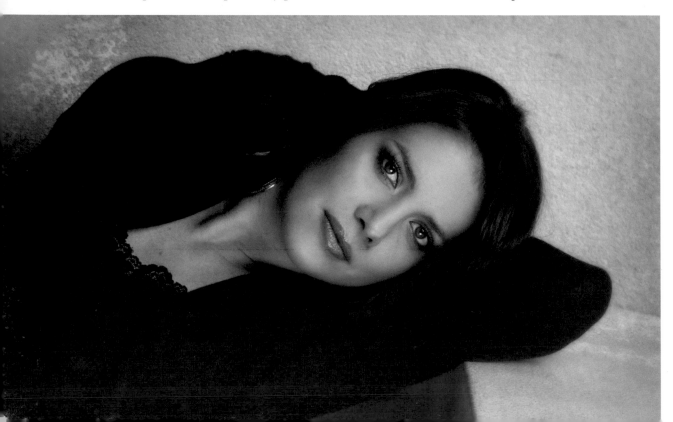

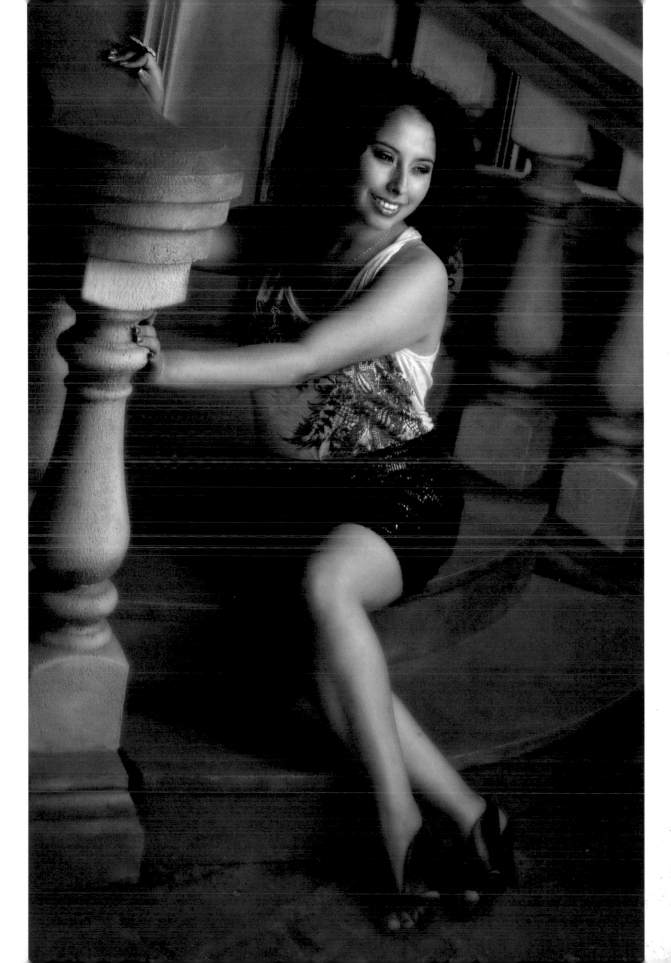

▼ FOR FURTHER STUDY

When the style of pose and background both suit the cloth-ing, the portrait will have a cohesive look.

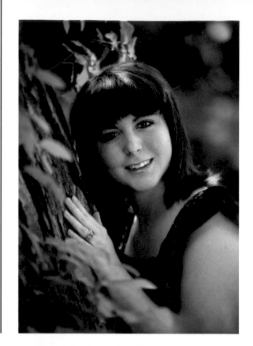

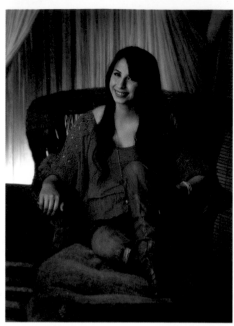

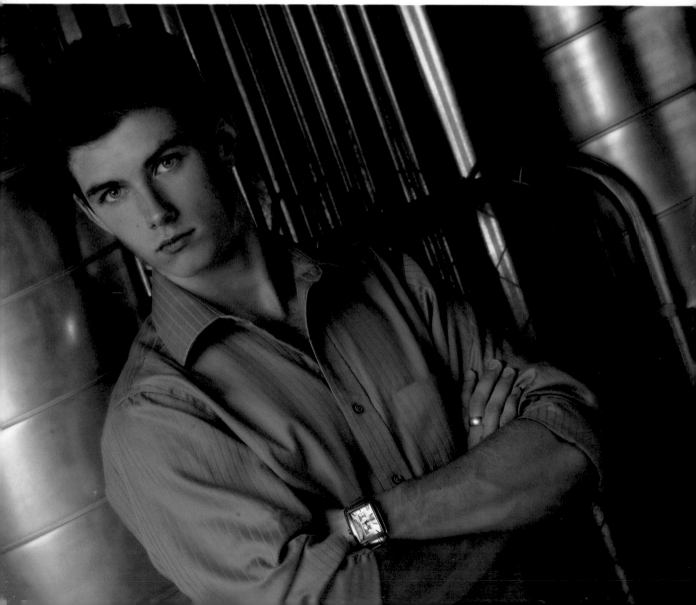

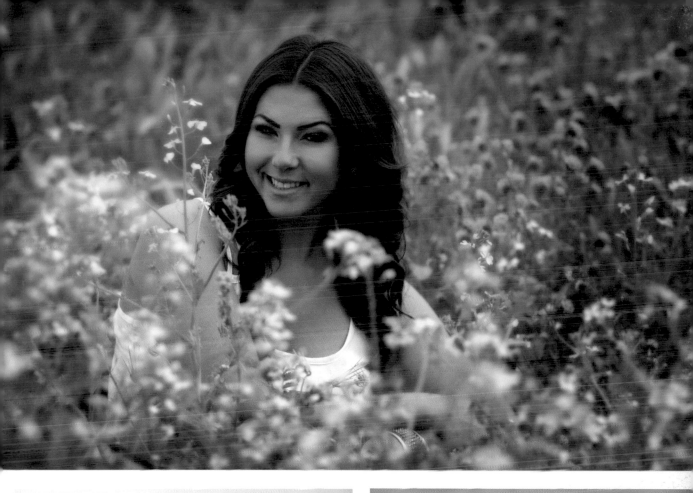

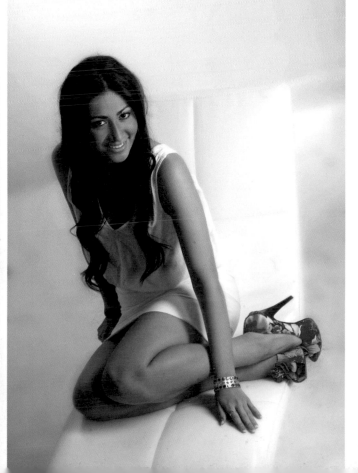

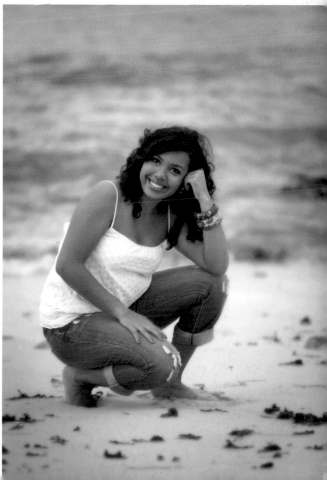

Women worry about every aspect of their appearance—from the tops of their heads to the soles of their feet. While this seems overwhelming for most male photographers, you have to realize that while women do worry about everything, they also worry about the *same things* as all other women.

WEIGHT

Knowing that most women worry about their weight, everything from the face to the feet should be posed in a side view with adequate shadow to subtract a little of the thickness.

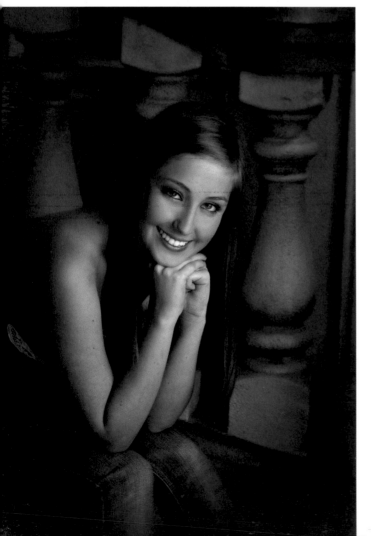

HIPS AND THIGHS

The most hated area of the body is, without a doubt, the hips and thighs. No woman ever wants her hips or thighs (including her bottom, but that will rarely show in portraits) to appear larger than they are—and most women would prefer shaving off a few inches from their appearance in the final portrait.

THE FACE

The face of is the focal point of all portraits, so women are always concerned the wideness of the face and the area underneath the chin. Positioning your main light and camera correctly can help this area tremendously. By turning the subject's body away from the main light source and then turning the face back toward the main light, you can stretch the loose skin under the chin/neck area. By elevating the camera angle (yes, the pose that camera phones and Facebook have made popular) and then having the subject raise her face to look at the camera, you again stretch out the loose skin of the neck and double chin, making the face appear thinner.

UPPER ARMS

Women are always concerned about their upper arms appearing large and/or flabby and the forearms having visible hair. Covering the arms is the

Pants are a safe choice for every woman and eliminate any possible concerns about how the legs will looks.

Many women worry about their upper arms. Long sleeves eliminate much of the concern—and posing them away from the torso ensures they will not bulge and look larger.

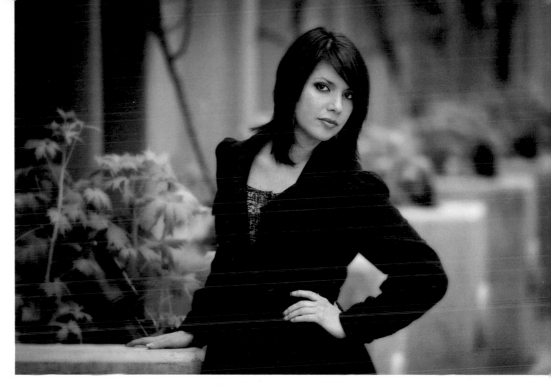

best strategy. Separating the arms from the body, so there is no pressure against them to cause enlargement, will also help.

HANDS

Women want their fingers to appear long and elegant —after all, not many woman get complements on their "sausage fingers." If a woman's hands are larger, have her hold onto something to minimize the area; if her hands look elegant, however, don't minimize the area.

WAISTLINE

If you're going to show the waistline in a portrait, it should taper in from the shoulders, then down and out to the hips. If the waistline is the same size or larger than either, it shouldn't show—or you should ask the woman to wear black and minimize the area.

LEGS

A woman's legs can be a source of considerable pride—or a source of embarrassment. If the woman has toned legs, she will probably want them to show in any full-length poses.

Having the subject wear nylons or tights can make the legs appear more slender and do away with signs of cellulite—but if the feet are going to show, the woman needs to wear closed-toe shoes. Nylons with open-toed shoes look just as bad as socks with sandals.

FEET

If a woman's toes don't get smaller (evenly and perfectly, of course) from the big toe to the pinky toe, her feet are considered an eyesore by many. Also, each toe must be perfectly shaped with no bumps or bulges. (With so much pressure to be perfect, it's amazing women ever leave the house—never mind have their portraits taken! I sure am glad to be a man.)

POSING WOMEN: EXAMPLE

Let's examine the complete process I used when posing an actual client for her portrait session.

LEGS

If you want to make your client look taller, find a way to make her legs appear longer. I think you are safe in thinking that if you make any woman's legs look longer, you will be her friend.

In this case, three things went into elongating the subject's legs. First, we selected shorter shorts to reveal more of her thigh. With more leg showing, the legs appear longer.

Second, having her wear very tall high heels extended the line of her legs by at least a few inches.

To finish off the portrait, I had her extend her bottom leg for maximum length. To add impact, I had her cross her top leg over her lower leg and lower her knee down to the floor. In the final portraits, she has legs for days.

BUST

The second posing enhancement I employed was to make her appear to have a larger bust than she really does. The apparent size of the bust in a portrait is determined by the size of the shadow in the cleavage area (refer back to lesson 33 for some examples of this). When you increase the size of the shadow, you visually increase the size of the woman's breasts.

The floor below her left breast and the arm above her right breast also work to bring both breasts closer together, increasing the appearance of their size in a very natural-looking pose. To me, this is much more effective than a pose in which the woman is obviously pushing her breasts together with her arms.

CAMERA POSITION

The final touch was selecting a unique camera position to further elongate the subject's body. Choosing a low angle created a warm and engaging view of the subject's subtle expression. Tilting the camera slightly transformed all the straight lines in the frame into diagonals, lending a softer look and creating a more dynamic composition. Adding a substantial vignette completed the look, keeping the viewer's eyes locked on the attractive subject.

THE PURPOSE, THE CLIENT

Again, let me emphasize that this type of enhancement is not appropriate for *every* woman. Some women would take offense at these kinds of enhancements and even the overall look of the portrait. That's why you must talk with each woman before her session to find out what she wants and who will be receiving the portraits from the session.

For example, if this young woman had wanted a portrait to give to her mother, she might have felt a little odd with this as the final image—but that was *not* her purpose and she was very happy with the enhancements I chose to use. Every client is different, but as a professional photogra-

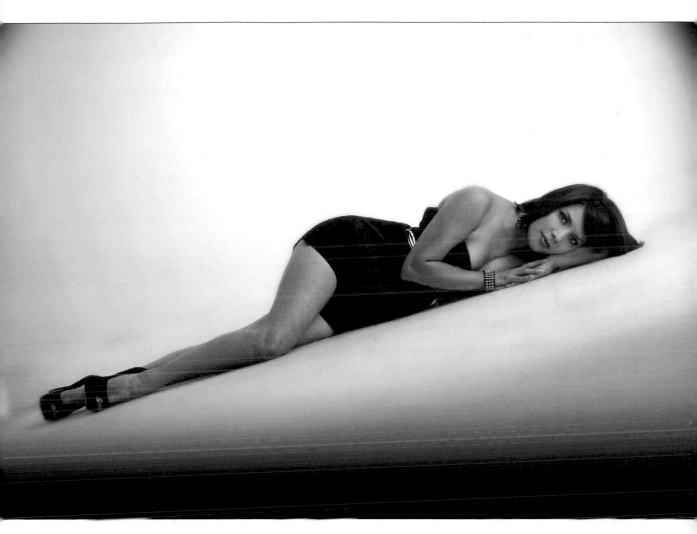

pher, you should be able to enhance a portrait to give each client a version of reality they can live with—and one that matches their purpose for creating the portrait in the first place.

Another important point is that, while this portrait is incredibly alluring and would certainly be enticing to any boyfriend or husband, the woman is fully clothed. Many photographers think "sexy" means showing a woman in swimwear or in clothing that would be more well-suited for the cover model of a biker magazine. Yes, women do want fashionable portraits and some want to look sexy—but you can learn to pose in

such a way that you create allure without having to show a lot of skin.

TIP ▶ We show our clients their images a few minutes after the session ends. I do this because I like making money from my images—and a client's excitement (*i.e.,* willingness to buy) is always highest right after the session. In my experience, photographers who learn the proper steps to take to show the client their images right after the session will see 20 to 30 percent increases in the size of their orders.

Whenever possible, don't sit a woman down as she would normally sit. When a woman sits in a chair in a normal sitting position, everything looks larger. The legs, hips, and bottom mushroom out because the body weight is rest on them. The legs also push up the stomach, which pushes up the breasts—adding to the appearance of more weight under the chin. Some larger women, when they are seated this way, will actually appear to have two breasts directly under their chin, not a good look.

As noted in earlier in the book, in seated poses you should always get the weight off the fleshy areas off the bottom, hips, and legs by having the subject roll slightly to place her weight on her hip bone. This slims the hips and thighs.

To further improve on the effect, you want to stretch out the body. Have the subject's bottom on one side of the chair and stretch her upper body to the other side of the chair. This keeps the abdomen from pushing up the breasts.

Finally, adjust the lighting and camera angle to higher elevation. Posing the face at a higher angle stretches out any loose skin under the chin.

TIP ▶ Remember that one foot must touch the ground in seated poses (unless you have both legs over the arm of the chair or in some other pose that doesn't need to be grounded). If the woman is shorter, have her come to toward the front of the chair until one foot can touch the ground.

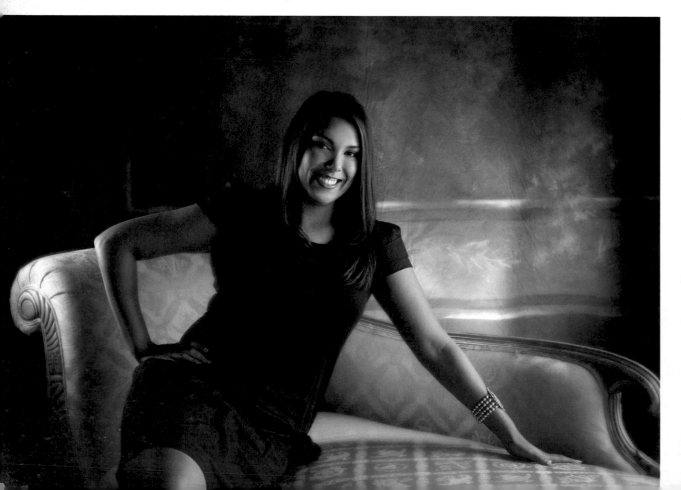

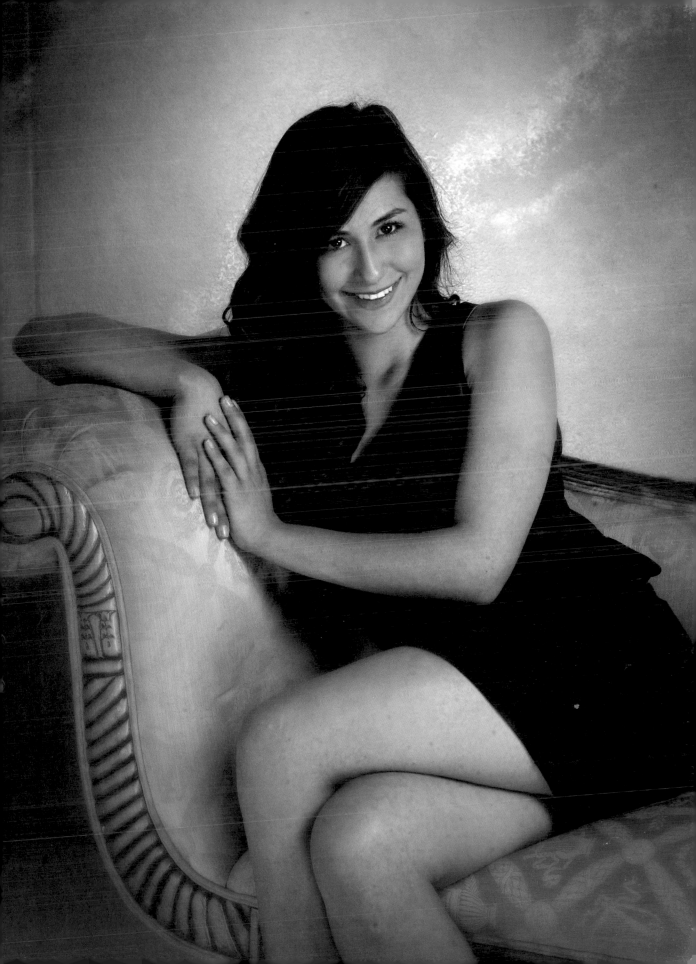

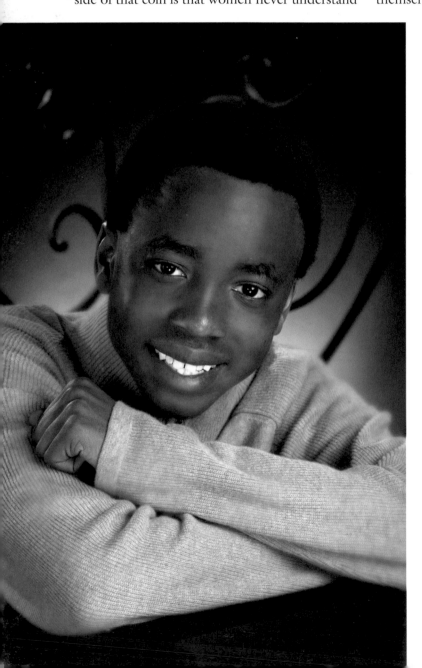

en tend to be somewhat rigid in their posing and much less tolerant of anything outside their comfort zone. Men want to look manly—and not be embarrassed. I always say that men have no idea how much women worry about in their appearance (unless they have a job like mine or are a plastic surgeon), but the flip side of that coin is that women never understand how much men don't want to be publicly embarrassed. This is important for female photographers to recognize.

Dancing is an excellent example of this difference. If you look out on any dance floor, you will see women dancing with other women, women dancing in groups, women dancing by themselves, and of course a few ladies dancing with men. The skill level of these female dancers ranges widely; some are excellent, some look like the Elaine character on *Seinfeld* (who appeared to be having random spasms that were totally unrelated to the beat of the music).

Now, if you look at the men on the dance floor, you'll see the guys that are great at dancing and those few men who are willing to risk embarrassment by doing something in public that they don't know how to do well. More than women, men tend to be very uncomfortable when they have to do something new—and they can feel downright "freaked out" when they have to do something new in front of other people.

So the first rule for posing men is to photograph them in a place that is comfortable to them. I am not suggesting you go to their home and photograph them in their sweats, sitting on the recliner and watching television—but you do need to consider this male tendency when you book a session.

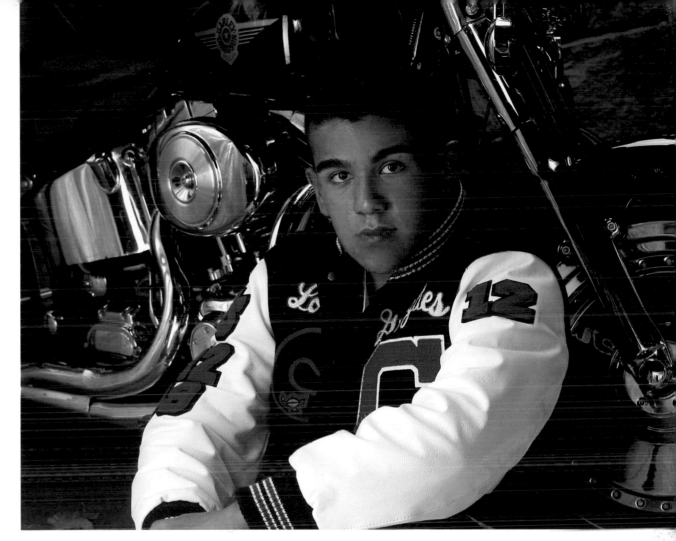

During a studio session, for example, you can make sure that other people are not around when you photograph any man. I work with assistants, but I only have one with me when I photograph a male. Furthermore, I try to use a male assistant, since men get more self-conscious in front of women—and especially the younger women I usually have work for me. (This is not a sexist thing or preference of age on my behalf; it just makes sense because I'm working with seniors all day!) With all of my subjects, I make sure that no other clients are watching the session or coming through the camera room—but I am *especially* conscious of this when photographing a man.

TIP ▶ When I photograph a man or men as part of a group outdoors, I select a more secluded location to avoid on-lookers and passersby. In a larger family portrait session during which we will also photograph smaller family groups, I ask any family members not being photographed to relax in an area out of sight from the family I am photographing. One problem with multiple men in a family location shoot is the ridiculous need for the man not being photographed to try and embarrass the man who is being photographed into smiling. Good smile, red face!

Once you make sure the male client has some privacy, the next step in achieving a comfortable pose is to select posing options that feel manly. Don't ask a man to lay on his stomach if he is a football-watching, potato-chip-eating kind of guy. This restriction is actually a good thing for posing because, by nature, men's poses are more structured and feel more "manly" when they are doing them. This adds to the comfort level of the man and he appears more relaxed and less stiff.

While there are many poses for guys illustrated in this book, you can really get a huge number of posing ideas simply by watching guys as they interact with people they are comfortable with.

If you do this, you have to be able to adapt what you see to something that their wife or mother will want to buy, because men are not the most refined of creatures.

For example, men like sitting with their legs wide open. Women often don't understand this (probably because they don't have anything between their legs to smash!), but these poses are great for guys, because men feel comfortable that way (I bet you never thought you would hear that in a posing book!). The key is to pose their open legs away from the camera. This also gives you the perfect base to rest the elbows. Now you are starting to create a believable man's pose that looks like a man.

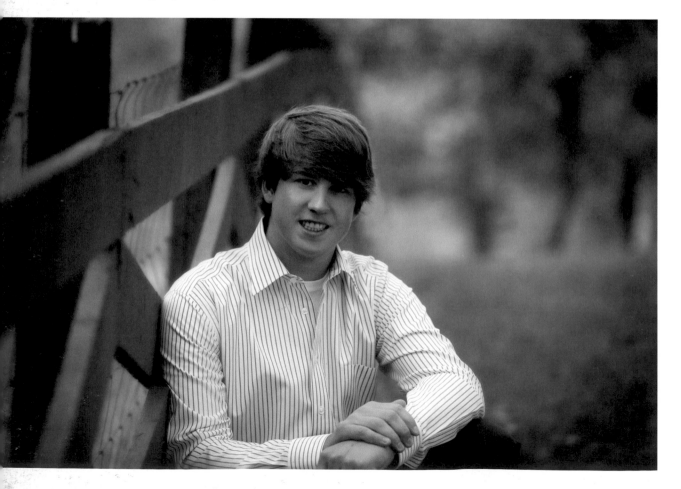

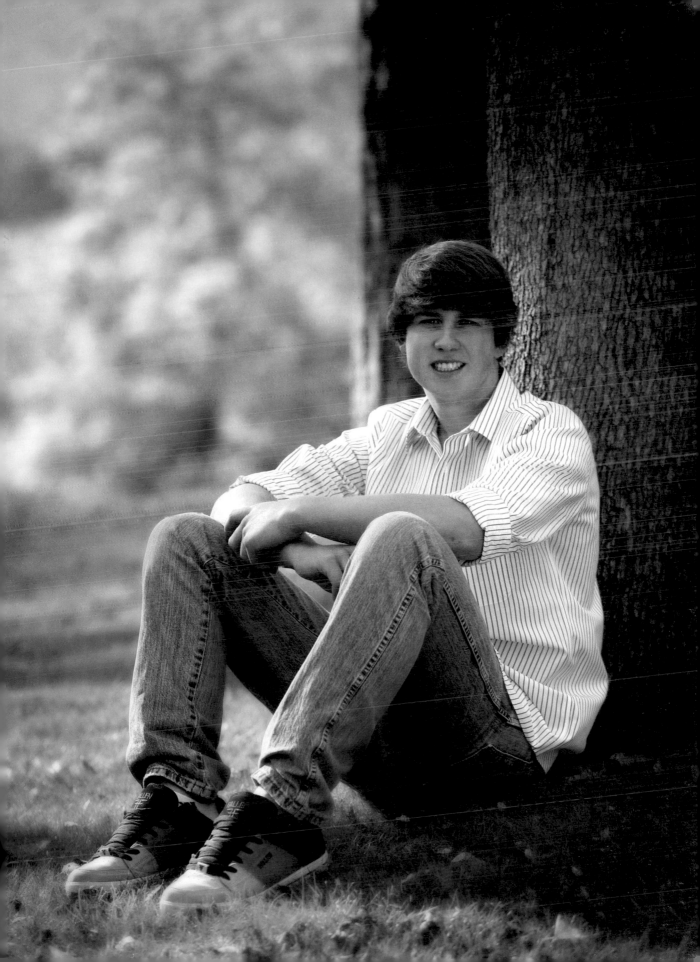

When it comes to
posing men, it's
critical that the pose
feels comfortable.
If it does, it will
probably look natural
and relaxed in the
final images.

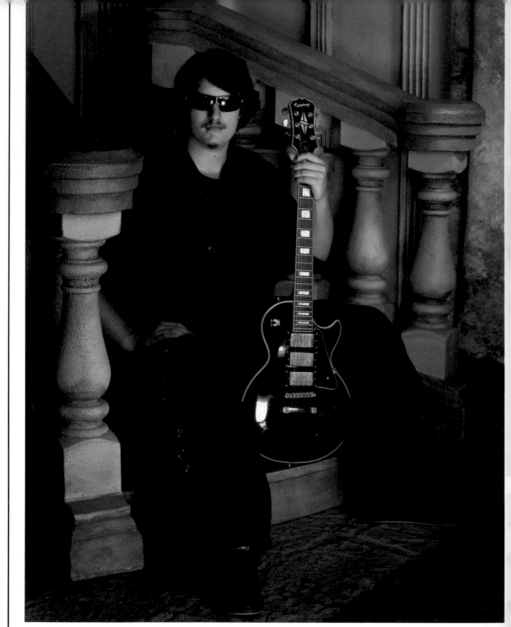

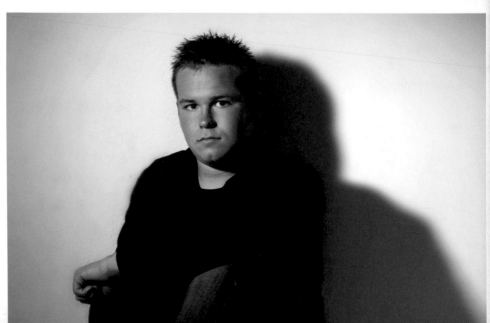

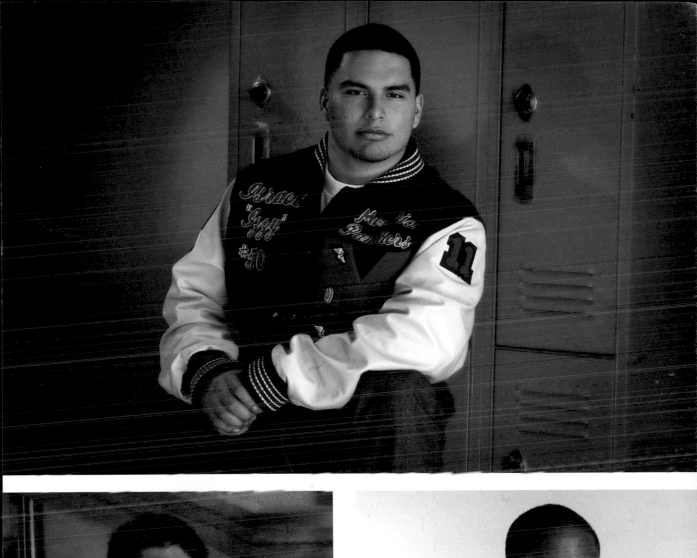

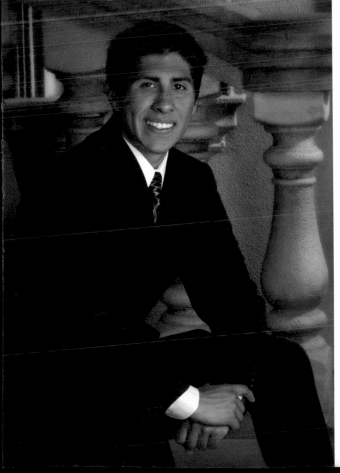

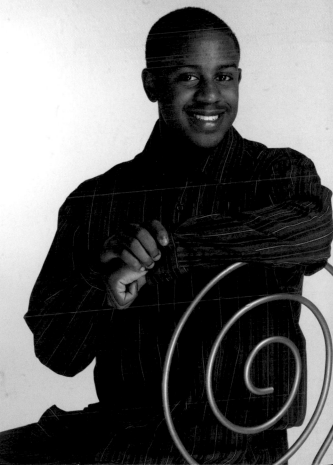

LET MEN BE MEN

This brings up another important part of posing men (and, for that matter, women). Just as we don't hesitate to make a woman look like a beautiful woman, we shouldn't shy away from making a man look like a man.

I don't drink beer, I don't watch sports on television (although I do have a Harley and a

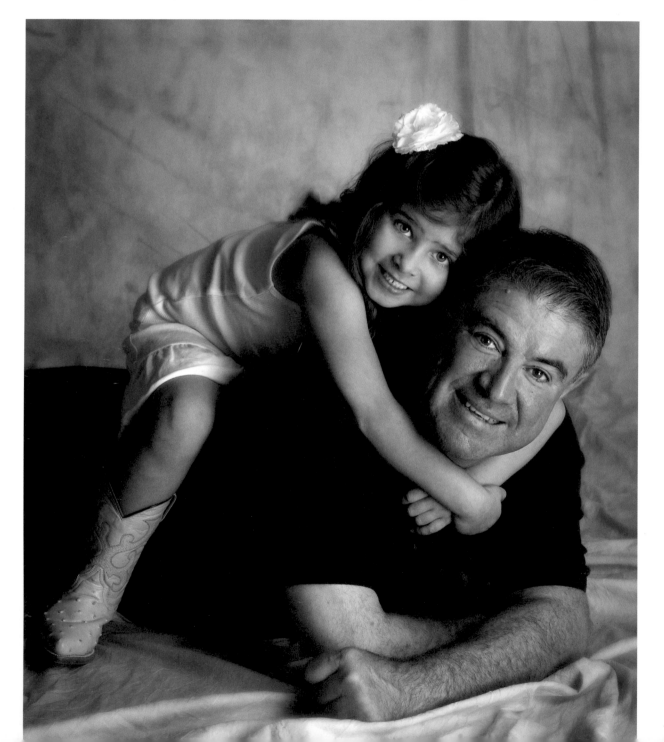

Viper), I really like stylish clothing, and I probably have more shoes than most women—but in a portrait, I want there to be no question of which team I play for! Even stylish, evolved men such as myself want to look manly. For most men, there is nothing worse than being posed in a feminine way in a portrait.

That said, your approach to posing men has to be adaptable. What's right will depend on the role you want to capture.

CONTROLLING THE LINES

Men's poses should be structured and strong when they are being photographed alone (unless a man happens to be very feminine in nature) or shown with their a family in the role of a husband or father. A man's posing should be softened when being photographed with a small child or in a romantic way.

By controlling the predominant lines of the body, you control the look of the pose. For a look of strength, you'll choose a pose with strong, straight lines. To soften the look of man's pose, simply round out or curve some of the straight lines. The degree you soften a man's pose is completely at your and your client's discretion. Often laying a man on his side or reclining is all that is needed to soften the look to match a child.

In the image above, you see a pose I did when my son was born (this was over twenty years ago, so if you see me at a program or convention don't expect me to look like this now!). Back then, I spent a great deal of time lifting weights and was told that I had a pretty intense, intimidating look. To soften that, I took the image in a pose where I was reclining back and holding my newborn son. My arms were more curved

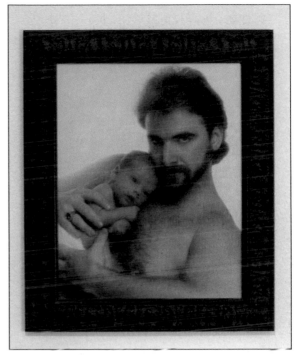

A portrait made over twenty years ago of me with my son. The softened pose helps communicate the gentle feeling of a parent toward a child.

than squared off, softening the pose to match the gentle feeling of a parent with his baby—not a muscle-bound dude trying to look macho.

THE PURPOSE OF THE PORTRAIT

Just like women, men have a variety of reasons to have photographs done, and each style of portrait needs to be posed differently. A business portrait will require different pose than a portrait of a man with his child—but even a business portrait can require different styles of posing based on the business the person is in. A hair stylist will want a different look than a banker, and a chef will require a different type of portrait than a real estate agent. Posing, just like all the other aspects of the session, has to be adapted to fit the type of portrait that is needed.

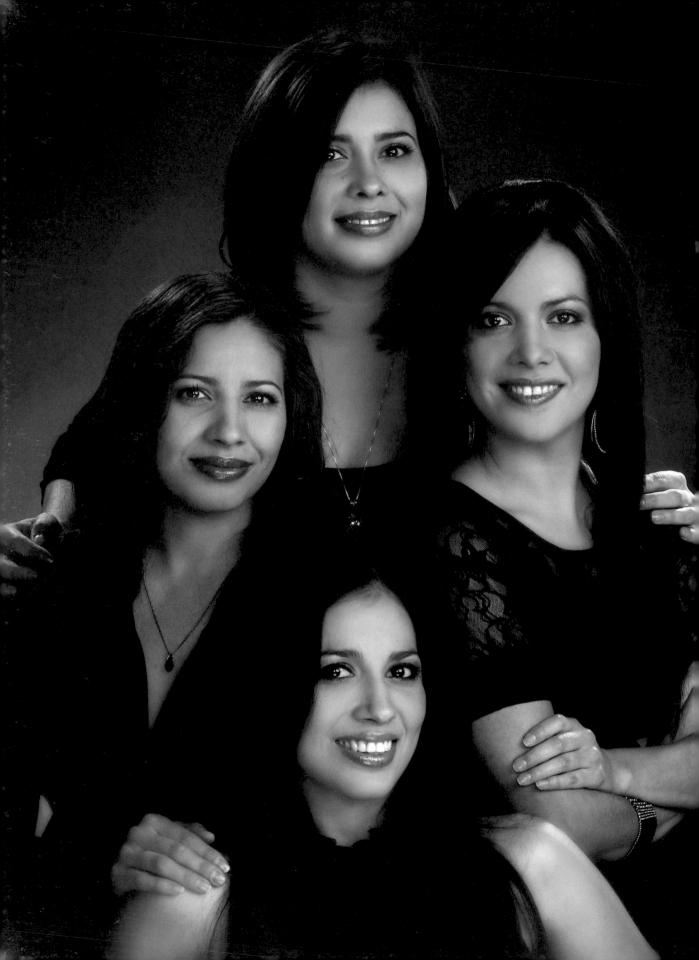

GROUP PORTRAITS: PLANNING

Working with families or groups can be challenging. You have the same process of posing each person—but you must also arrange all those perfectly posed clients into an interesting configuration within the frame. Each person must also have a great expression individually and coordinate logically with all the rest of the people in the group.

THE CLOTHING

In group portraits, the clothing styles and colors have to coordinate; otherwise, the viewer's attention will be drawn to the clothing, not the subjects. It looks odd to have everyone in jeans except one family member who decides to arrive in a suit. If everyone is in white shirts and one person wears black, it draws the attention to the black shirt.

It is also important to not date family portraits by selecting clothing that is too trendy; simple, classic attire is best. Family portraits are displayed for a long time and need to be as timeless as possible. You don't want to create an image that ends up in the closet after a few years because it is so obviously dated-looking. If you do your job correctly, in twenty years the only dated part of the image should be hair styles—and the aging of the people!

THE SCENE

Next, you must choose a background or scene, as well as a posing style, that works with the clothing choice. If you don't consciously coordinate every element that appears in the frame, the portrait won't make sense visually.

For example, have you ever seen a man in a suit or a woman in a elegant gown sitting on the ground for a formal portrait? Me neither. Small children, on the other hand, are depicted sitting on the ground in all types of clothing. So if it's a more formal image and someone must be on the ground, the children are the ones to do it.

On the other hand, for a more relaxed portrait in casual clothing and comfortable surroundings, sitting everyone on the ground may be perfectly fine (provided there are no mobility issues; if Grandma is in the portrait, she may have a hard time getting up or down). The ground works especially well when you are photographing a family with children or babies. Most young families spend a lot of time on the floor/ground and feel comfortable there—as long as it isn't wet or excessively hard and uneven.

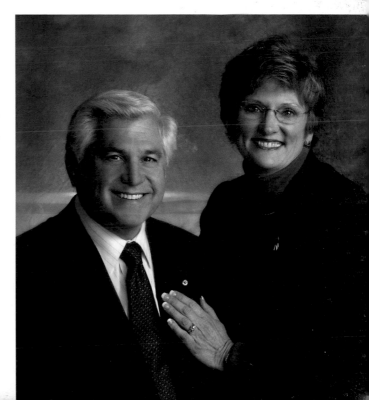

IDENTIFY THE PREDOMINANT PERSON

I typically start planning a group (over two people) by identifying the person of most importance in the portrait. This could be a newborn baby, a grandmother, a mother or father, a hus-

> **TIP** ▶ If there is no predominant person—say, when photographing four sisters, where each one should be equal to the others—I choose a non-centered, more linear posing so that no one is in the center, becoming the focal point. For these compositions, start your posing at the edge of the composition rather than the center. I like using diagonal lines and modifying them for siblings, as it visually makes each person of equal status within the frame.

band or wife—it will depend on the reason the client has hired you.

If they are hiring you to take a small family portrait because they've just had a new baby, the baby is the most important person in the portrait. If the portrait is being taken because the grandmother is celebrating her ninetieth birthday, she is the most important person in the grouping. Portraits that are created for Mother's Day or Father's Day are obviously self-explanatory.

In an average American home, with two parents and 2.2 kids, the father is traditionally given the predominant position. It doesn't matter if you don't agree; it's what an overwhelming number of your clients will want and expect to see in their images.

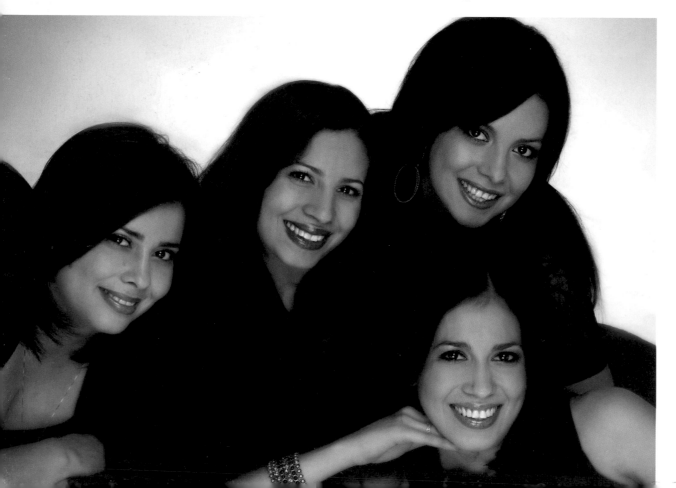

POSE THE PREDOMINANT PERSON

I look at the best way for the predominant person to be posed. Sometimes, the abilities of the subject will determine the approach. For example, if your predominant subject is a newborn, you might choose a raised, secure posing surface that would give you the most options for the family members to be posed around the baby. If the predominant subject is a ninety year old grandmother, the ground is out of the question. (After all, people don't look comfortable in places they can't normally go—and no one at any age feels confident being hoisted down and up from a pose!) For an older person, even standing for prolonged periods of time may not be an option, so I typically bring in a chair or stool for the subject.

If the predominant person has no movement restrictions, the next consideration is their clothing. If everyone is dressed in suits and elegant dresses, posing on the ground isn't a option. However, if the person of predominance is in jeans, the ground or posing areas near the ground (large branches, tree stumps, etc.) will perfectly suit the more relaxed style of clothing.

POSE THE REST OF THE GROUP

Once I have decide on the placement of the central person, I start posing each person around them, making sure the basic spacing is consistent and that no one's head is at the same level—more on this in the following sections.

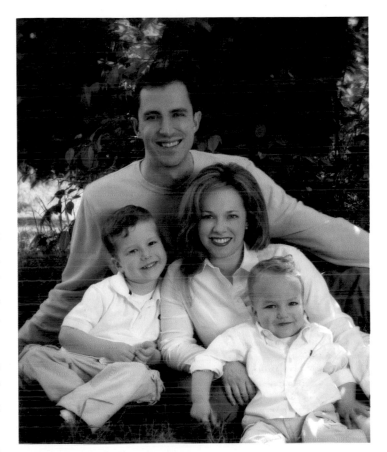

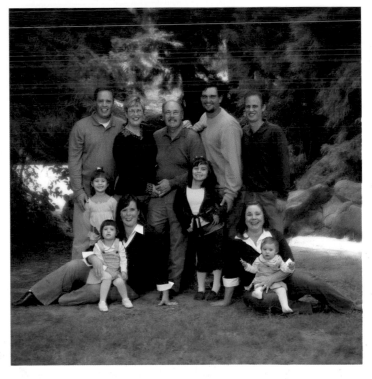

▼
FOR
FURTHER
STUDY

Dressed in red, the parents keep your attention even when they aren't placed centrally in the composition. Notice how many posing variations can be created with a small group in a single area. This gives your client a lot of options when it comes time to order.

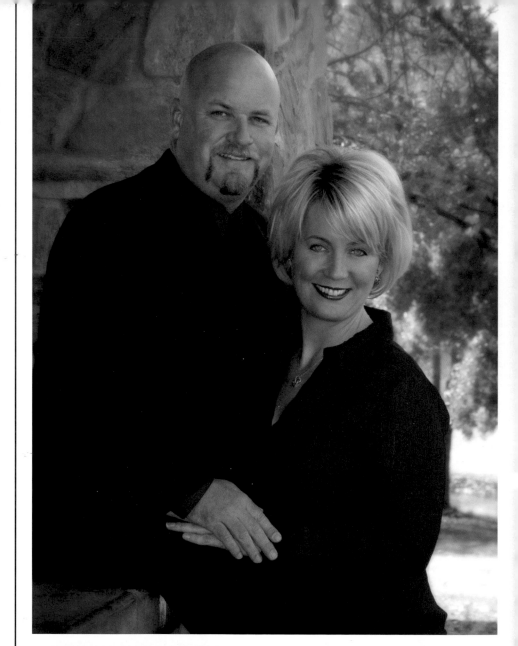

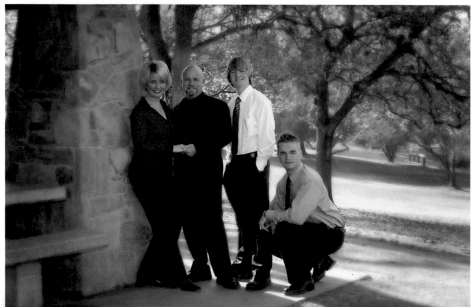

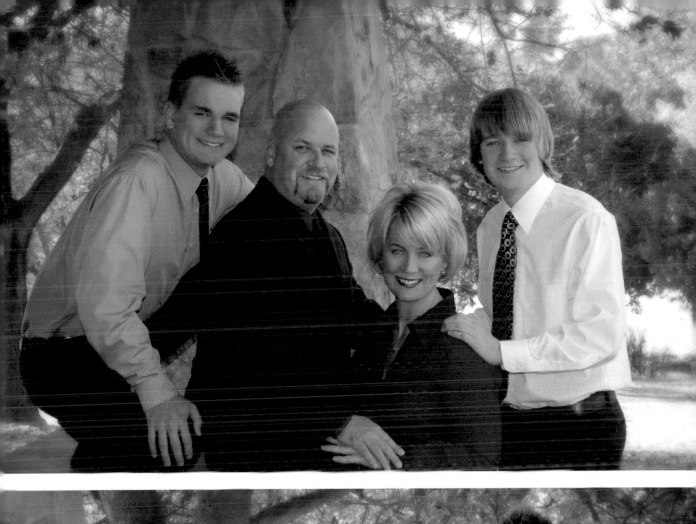
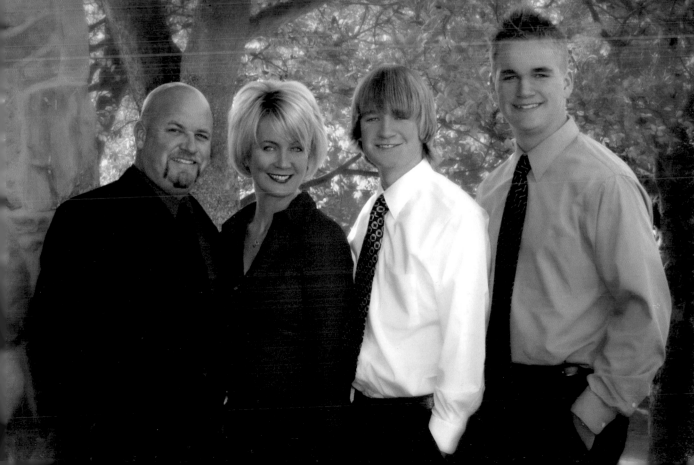

CLOSENESS

How close should you pose the people in the group? There are several factors to consider. First, you might want to choose a close grouping if there is a baby in the photo, lowering the adults down to the level of the baby. Tighter groupings are also good for families who want to create a sense of closeness in their portrait. Because closer groupings also isolate a small amount of a scene or background, they can be used when you don't need or want to show much of the setting. If, on the other hand, your client wants to show more of the scene or wants large props (horses, cars, ATVs) in a pose, then the grouping will have to be spaced out to maintain a good composition.

Today, many people have weight issues, so I tend to pose each person closer together to fill the frame with more faces than bodies. One of the challenging parts of this is that you have to pose each body to look good without getting in the way of the next person you are posing. Also, you must make sure that the individuals don't look uncomfortable touching their family members. Guys are often weird about this, but you can explain, "She's your sister—just relax."

SPACING

Whether you are photographing three people in a close head shot or ten people in front of their house with horses, the spacing between each of the people within the frame needs to be reasonably similar. You don't have to take out a measuring tape; I said *similar*, not *exact*. If one person is noticeably further from the rest of the members of the group than everyone else is, she or he will look like an outcast. To keep people at a similar distance visually, look to the faces.

The proximity of the subjects helps convey their relationship. Romantic pairings call for closer poses (left), while two friends can be posed with more space between them (facing page). Here, just their arms are touching to connect the pair.

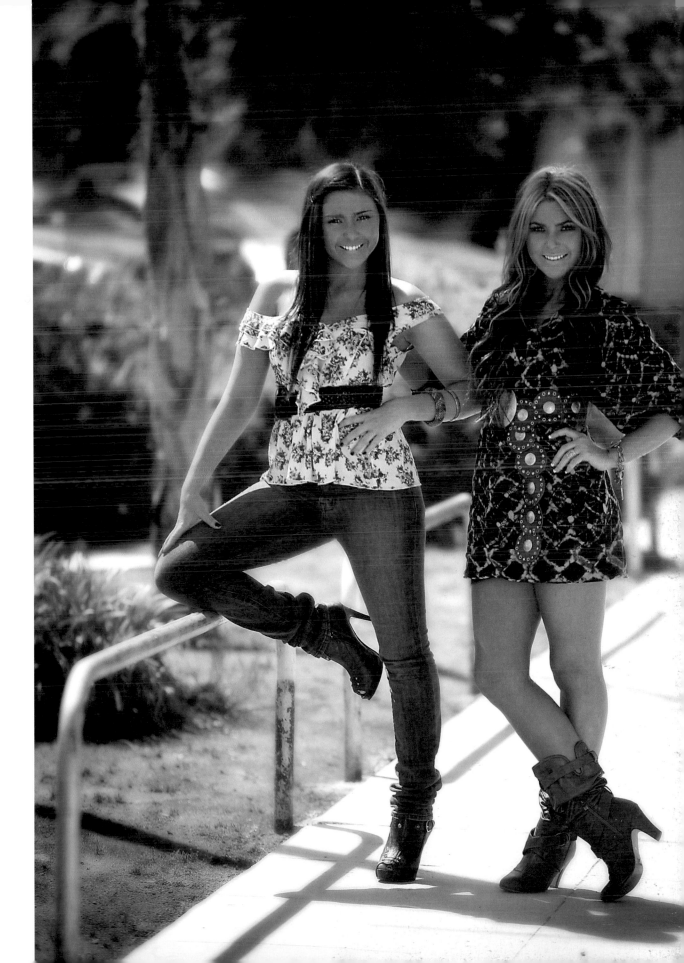

You should avoid having anyone's head on the same level as another person's head. This can be challenging with larger groups, but

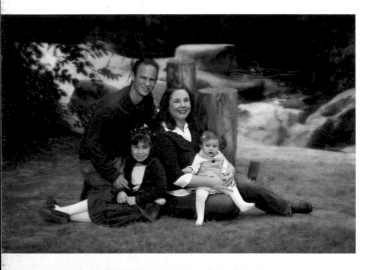

it keeps the pose and composition from looking like a lineup. With fifty people, your posing options are limited, and you might have several people at the same height, but that's just life; sometimes art must suffer when you need to photograph a crowd.

In a photograph of two people, the mouth of the higher subject should generally be at about the same level as the eyes of the lower subject. As you add more people to the composition, you may need to select a different point of reference—it may be that the eyes line up with the chin, or the top of the head lines up with the mouth, etc. Keeping this guideline in mind will help you to place each person within the group.

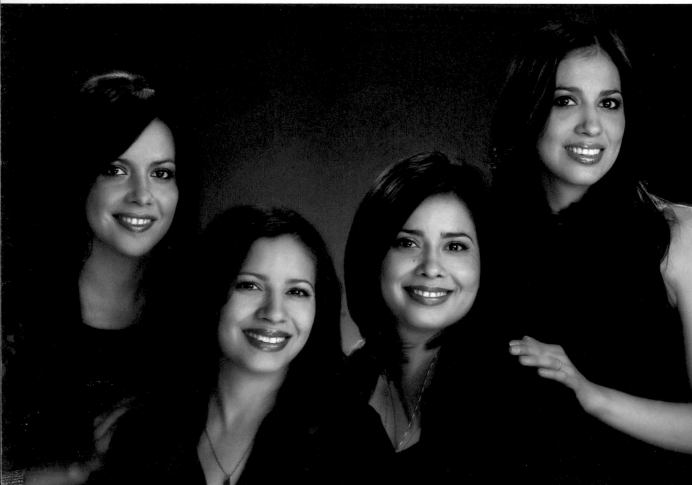

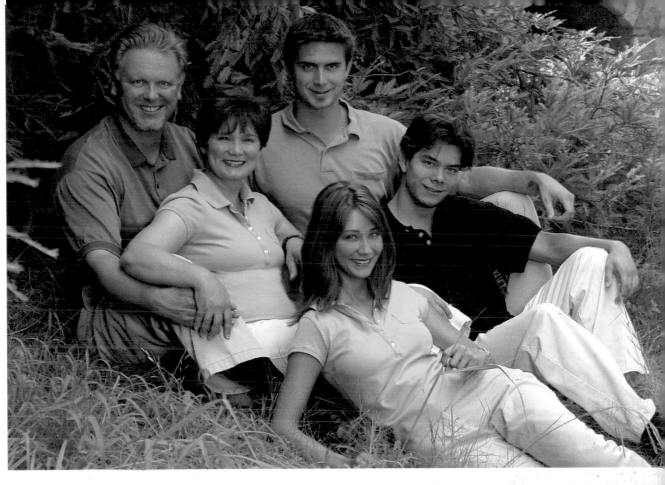

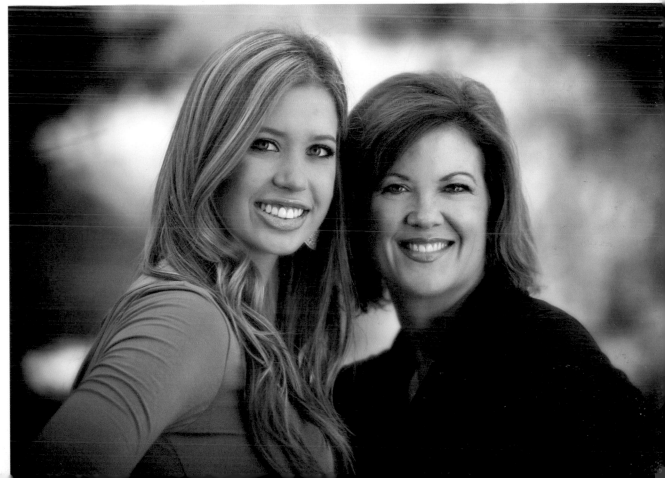

STYLE OF POSE

When posing a couple or group, you want to have the same posing style for each person. You shouldn't have everyone in traditional posing with one person in a more fashionable pose, unless you intend to draw attention to that person.

EXPRESSION

Another important consideration is expression. When working with one person, it is easy to talk with the person and let your words, tone, and the expression on your face guide the single subject to the proper expression.

In a group portrait, you need to tell everyone what expression you want, then let the words, tone, and expression on your face enhance the expression. Many people feel more uncomfortable in groups and don't pay attention to subtle direction, so tell them very clearly what you want them to do.

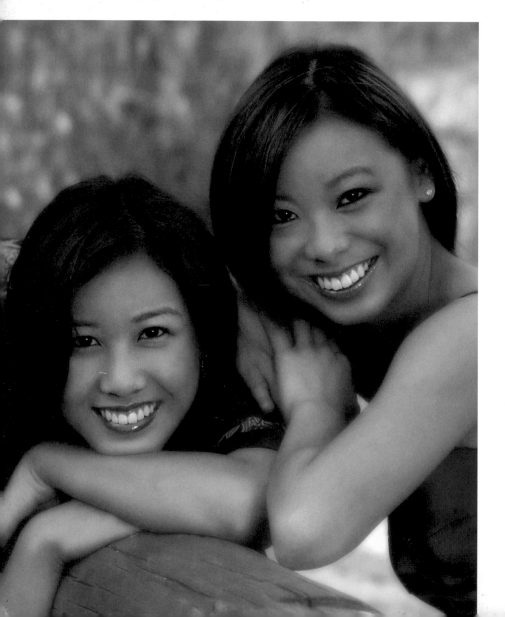

TIP ▶ It is important to identify the groupings and portraits you will be taking for the sitting fee you are charging. In larger families, you always have at least one person who will yell out when you are done, "Now let's take this photo and that grouping!" If you fall into this trap, you will be spend hours taking every possible grouping and item of interest down to a head shot of the family cat. We are professionals and get paid for our time. You must clearly define what is included in the price you quote and how much each additional grouping will add the session fee.

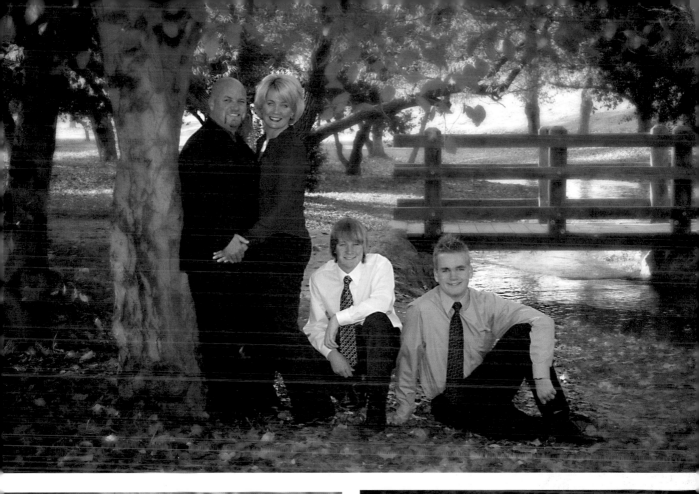

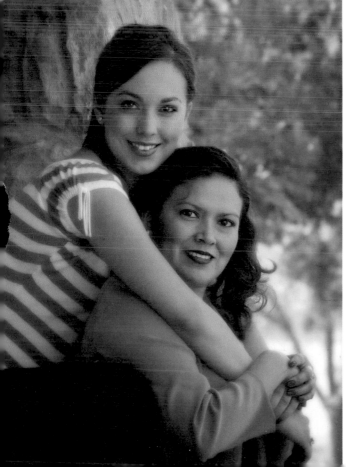

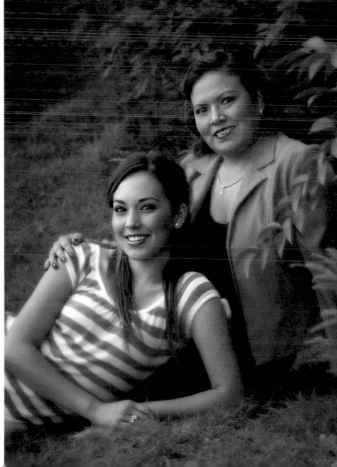

CONCLUSION: THE FINAL STEP

After reading this book, you should have a strong fundamental understanding of posing and how to pose people for the best possible portrait. While this book is coming to an end, however, your learning process is just beginning. Posing can't be completely mastered—or even completely understood—without practice.

I have had young photographers say, "You are clearly a master of posing and your twenty-three years of experience show in the way you photograph your clients—but I don't have twenty-three years. How do I master posing *now*?" Many photographers feel the same way; they want to master everything *now*! Well, I have good news and bad news for you. The bad news is that you can't master posing in a matter of days or weeks. It is a learned craft—one that you keep learning and improving on throughout your career. The good news, however, is that the speed at which you learn posing is based completely upon *you*.

If you read this book, put it on your shelf and do nothing further with it, your path to posing mastery will be a long one. Instead, schedule some sample sessions with non-perfect people (people who don't self-pose or want to be the next top model). Pose them in every shot, taking responsibility for everything within the frame.

If you keep practicing, you will learn posing quickly. You will see improvement in your work every week. Little wrinkles and bulges and other imperfections that you used to have to fix in Photoshop will now be something you correct for during the session.

Basically, I have done my job, Grasshoppa', and now it's up to you. You can become a posing master or stay right at the level you are now—the choice is yours!

I can tell you this: when you have mastered anything, the feeling of accomplishment is always greater than the work it took to master it. Too often, people put off things that they think will be difficult. Once they get up off the couch and start working on accomplishing their goals, however, they find that all their worry about the difficulty of a task was much worse than actually completing the task. So get up, practice, and keep practicing. I have been at this a long time and I still practice at least once a week. Get busy!

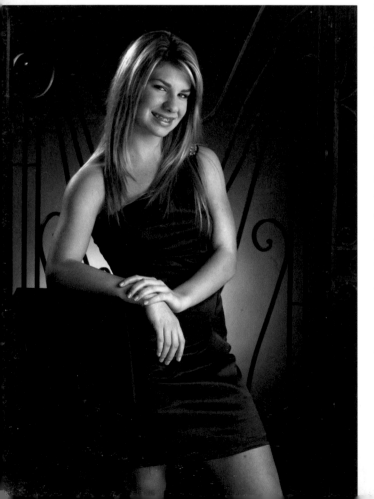

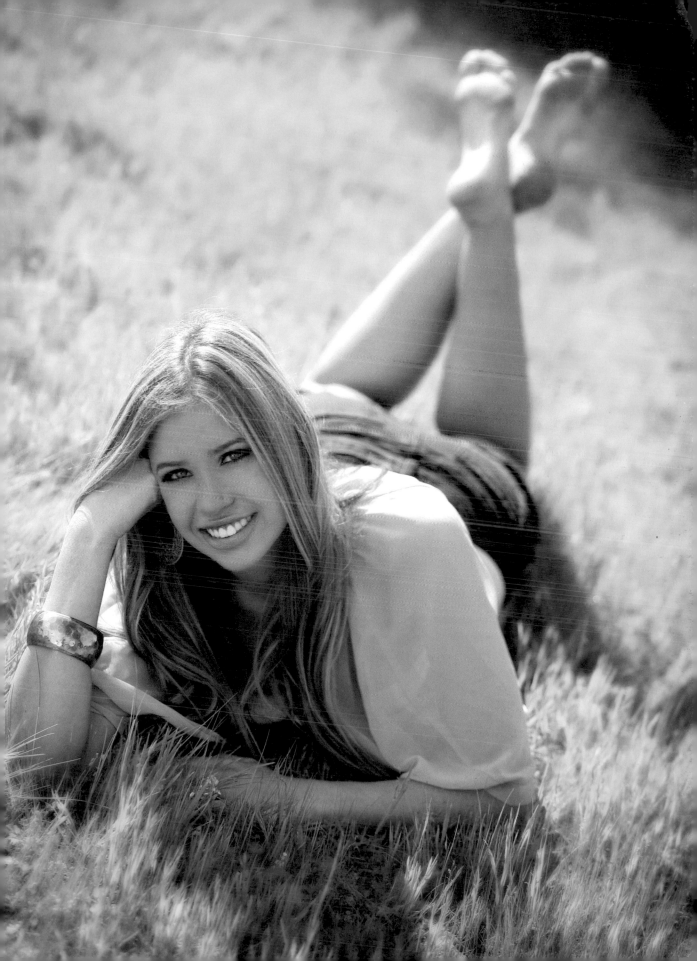

INDEX

The Portrait Photographer's Guide to Posing, 2nd Ed.

Bill Hurter calls upon industry pros who show you the posing techniques that have taken them to the top. *$34.95 list, 8.5x11, 128p, 250 color images, 5 diagrams, index, order no. 1949.*

Multiple Flash Photography

Rod and Robin Deutschmann show you how to use two, three, and four off-camera flash units and modifiers to create artistic images. *$34.95 list, 8.5x11, 128p, 180 color images, 30 diagrams, index, order no. 1923.*

CHRISTOPHER GREY'S
Lighting Techniques

FOR BEAUTY AND GLAMOUR PHOTOGRAPHY

Use twenty-six setups to create elegant and edgy lighting. *$34.95 list, 8.5x11, 128p, 170 color images, 30 diagrams, index, order no. 1924.*

UNLEASHING THE RAW POWER OF
Adobe® Camera Raw®

Mark Chen teaches you how to perfect your files for unprecedented results. *$34.95 list, 8.5x11, 128p, 100 color images, 100 screen shots, index, order no. 1925.*

BRETT FLORENS' **Guide to Photographing Weddings**

Learn the artistic and business strategies Florens uses to remain at the top of his field. *$34.95 list, 8.5x11, 128p, 250 color images, index, order no. 1926.*

Just One Flash

Rod and Robin Deutschmann show you how to get back to the basics and create striking photos with just one flash. *$34.95 list, 8.5x11, 128p, 180 color images, 30 diagrams, index, order no. 1929.*

WES KRONINGER'S
Lighting Design Techniques

FOR DIGITAL PHOTOGRAPHERS

Create setups that blur the lines between fashion, editorial, and classic portraits. *$34.95 list, 8.5x11, 128p, 80 color images, 60 diagrams, index, order no. 1930.*

DOUG BOX'S
Flash Photography

Master the use of flash to create perfect portrait, wedding, and event shots anywhere. *$34.95 list, 8.5x11, 128p, 345 color images, index, order no. 1931.*

Wedding Photographer's Handbook, 2nd Ed.

Bill Hurter teaches you how to exceed your clients' expectations before, during, and after the wedding. *$34.95 list, 8.5x11, 128p, 150 color images, index, order no. 1932.*

Off-Camera Flash

TECHNIQUES FOR DIGITAL PHOTOGRAPHERS

Neil van Niekerk shows you how to set your camera, choose the right settings, and position your flash for exceptional results. *$34.95 list, 8.5x11, 128p, 235 color images, index, order no. 1935.*

Wedding Photojournalism
THE BUSINESS OF AESTHETICS

Paul D. Van Hoy II shows you how to create strong images, implement smart business and marketing practices, and more. *$34.95 list, 8.5x11, 128p, 230 color images, index, order no. 1939.*

THE DIGITAL PHOTOGRAPHER'S GUIDE TO
Natural-Light Family Portraits

Jennifer George teaches you how to use natural light and meaningful locations to create cherished portraits and bigger sales. *$34.95 list, 8.5x11, 128p, 180 color images, index, order no. 1937.*